Drinking with Chickens

FREE-RANGE COCKTAILS FOR THE HAPPIEST HOUR

· KATE E. RICHARDS ·

RUNNING PRESS
PHILADELPHIA

Running Press
Hachette Book Group
1290 Avenue of the Americas, New York, NY 10104
www.runningpress.com
@Running_Press

Printed in Singapore

First Edition: March 2020

Published by Running Press, an imprint of Perseus Books, LLC, a subsidiary
of Hachette Book Group, Inc. The Running Press name and logo is a trademark
of the Hachette Book Group.

The Hachette Speakers Bureau provides a wide range of authors for speaking events.
To find out more, go to www.hachettespeakersbureau.com or call (866) 376-6591.

The publisher is not responsible for websites (or their content) that are not
owned by the publisher.

Print book cover and interior design by Celeste Joyce

Library of Congress Control Number: 2019950736

ISBNs: 978-0-7624-9443-9 (hardcover), 978-0-7624-9442-2 (ebook)

1010

10 9 8 7 6 5 4 3 2 1

Yes, as a matter of fact, I am dedicating this
book to my chickens.

*Oh, also my husband. Because he puts up with
stuff like my dedicating a book to chickens.*

Table of
Cont

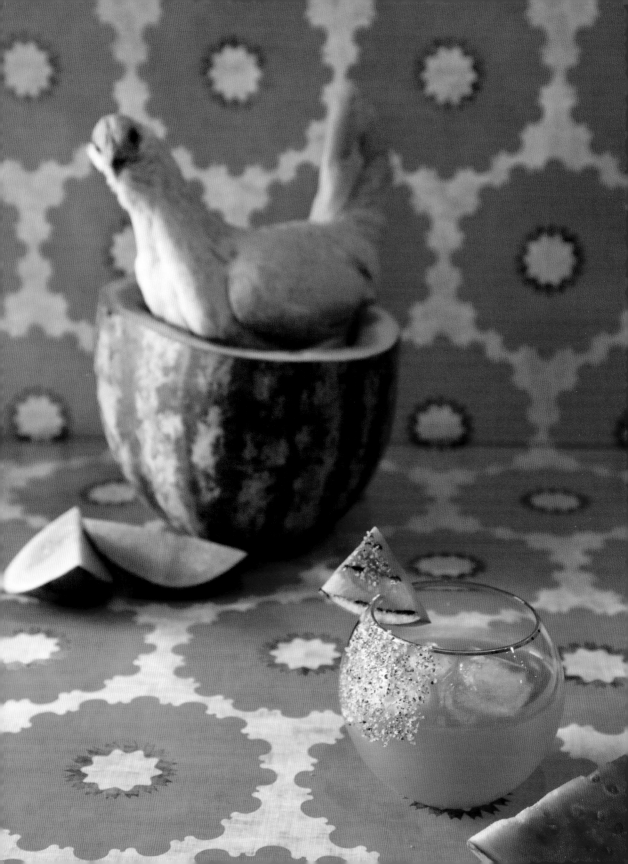

Introduction

TO DRINKING
WITH CHICKENS

Historically, *drinking with chickens* is one of the most enigmatic subcultural practices that has diffused its way across many cultures, over the course of many millennia. Since the dawn of Mesopotamian agriculture and the domestication of farm animals (coincidentally, around the same time we see the advent of beer production), drinking and chickens have gone hand in hand; legend has it that the Sumerian goddess of beer, Ninkasi, assumed the form of a chicken to pass safely through the Seven Gates of the Underworld. During the late Ptolemaic period, the ancient Egyptians devised an incredibly sophisticated method of artificially incubating chicken eggs. Vast networks of clay ovens were tended day and night by egg keepers who endured the long hours of isolation by drinking fortified wine. In medieval France, couples celebrated their betrothal by sharing a glass of wine and a piece of fruit in the presence of a rooster and a hen to symbolize their forthcoming wedding.

HAHAHAHAHA. Lies. All lies. Drinking with chickens is just a completely ridiculous thing I do in my backyard.

Is it a hobby? NAY. *It is a lifestyle, my friends.* Allow me to explain.

After many months of appropriate immersion therapy (double-tapping bucolic Instagram accounts, flipping through magazines, and pinning tirelessly to your Pinterest board, creatively entitled "CHICKENS!!!"), you may think: I'm going to get chickens! Usually, this decision is based squarely upon the noble idea that you'll be able to harvest your breakfast from these sassy, winged beasts. Fresh eggs. Every. Damned. Morning. *What could possibly go wrong?*

Well, let me walk you through a typical day for me:

The very millisecond the Eastern night sky shows even the tiniest twinge of morning light (let's call it dawn), the muttering starts. Whether it's five a.m., six a.m., or even seven a.m., depending on the season and the tilt of Earth and science and all that, the chickens wake with the very first signs of daybreak. They aren't heavy sleepers. The early morning muttering soon gives way to outright hollering as they demand to be freed from their coop to be fed. It is at about this time, each and every morning, that I put my pillow over my head and pretend that I don't have chickens.

Three minutes of denial pass by and it becomes impossible to ignore my chickens screaming at the top of their lungs. S. C. R. E. A. M. I. N. G. Probably hard for my neighbors to ignore as well, so I stumble blindly through the yard in my pajamas to release the caged banshees from their prison of emotions. I dutifully distribute the highest-quality organic feed into their Pinterest-worthy custom raised dishes. They briefly inspect, and then promptly turn their little ingrate, feathered backs on me to dig in the dirt for worms. I've just been given the chicken middle finger. I'm used to it, though.

Wearily, I trudge back inside the house to drink coffee and stare blankly at my computer screen in an attempt to start my day. It's so lovely to be up and at it so bright and early! *Said not me ever.* I "work" like this for a precious half hour of peace. It probably isn't even seven a.m., and we move on to Phase 2 of the morning.

My train of thought is brutally derailed by sudden and emphatic squabbling in the chicken yard. They are arguing over who gets to use the nesting box first. Despite the fact that there are several perfectly viable nesting boxes, they bicker over one just to be able to bicker over something. I try to focus on my breathing and determinedly get back to work. The squabbling waxes and wanes. I monitor the volume while adding bourbon to my coffee.

Around 7:30 a.m., the arguing swells into a migraine-inducing cacophony painfully unfit for early morning suburbia and I hurry back out to the hen yard to referee. One hen has laid her egg and is screaming about it, while three more stand in line waiting for her nesting box and scream back at her. I remove the first hen; no need to brag, keep it moving, Veruca Salt. There is a desperate scrabble for the empty box and Princess Vespa is the swiftest, settling her fluffy butt into place as Beatrix Potter and Frau Farbissina grumble poultry profanities at her. I lift Beatrix into a different nesting box, and Frau into a third. Can't we be reasonable, ladies? No. No we cannot. They hop directly out, squawking indignantly at me as they go to huff and puff at Vespa while she tries to concentrate on her egg.

Fifteen minutes and countless expletives later, I decide that refereeing was an absolute exercise in futility. I return to my desk to furiously hate-type at the computer and gulp bourbon coffee. The rest of the morning is spent rinsing and repeating.

Around noon, I realize that the backyard has returned to a more pastoral state. The girls have all cycled through their turns at dropping an egg (then boasting about it incessantly at the top of their lungs), and I am lured back out by the peace to watch them happily chickening about in their yard. They're so cute that I've already forgotten the morning trials. It's a little thing I like to call Chicken Stockholm Syndrome.

It's now about that time of the day for me to get some work done in the main garden. Lulled into a false sense of security by their happy little hen antics, I decide to turn the chickens loose for some free ranging time as I work. After all, they're pretty efficient weeders. And debuggers. And diggers. And *dear-Gawd-what-was-I-thinking-they've-destroyed-*

everything. Just like that, I regret all of my life decisions. I intercept the devil birds just as they've toppled a tomato tower, snapping the plant at its base. Tomatoes roll everywhere, followed closely by gleeful chickens. *Oh, the carnage!* Through a torrent of profanities, I rescue five ripe tomatoes. Barely. The rest are being ruthlessly eviscerated by a herd of tiny dinosaurs.

It's time for a cocktail. A tomato-based cocktail. Shortly, I return to my garden with a freshly made Spicy Tomato Vodka Soda, and as I sip on it in the fading afternoon light, I care just a little tiny bit less that now they've eaten all of my geraniums and that we will do this all again tomorrow.

A little-known side effect of chicken keeping is that you inexplicably wind up spending a lot of time just sitting in your yard, staring at your birds. Like a total creep. You may think you won't, but trust me, you will. Oh, how you will. So, you might as well sip on a lovely little cocktail while you do it.

JAZZ HANDS And that, my friends, is why: *Drinking with Chickens*.

Really, I'm just a girl, standing in front of you, holding a cocktail while her ankles get pecked, asking you to ignore the fact that none of this makes a damned bit of sense.

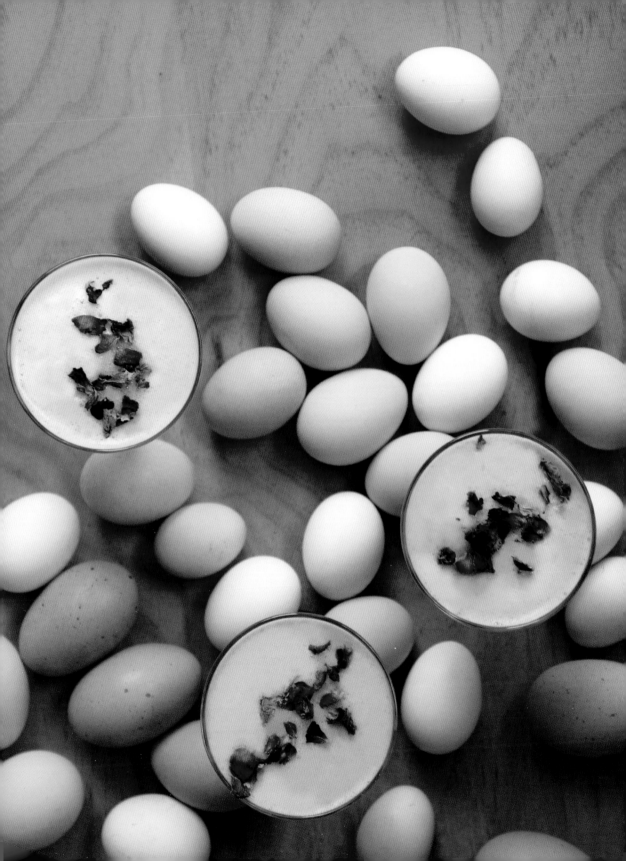

GARDEN-TO-GLASS
Cocktailing

AND ALSO
CHICKENS

It's pretty easy for me to talk about growing all your own cocktail ingredients and garnish in your backyard while I sit here luxuriating in my Southern California eternal growing season. I know, I know. For the record, I might be able to grow tomatoes through the winter, but it gets too hot for them here in the summer. *For tomatoes*. The grass is always greener, right? Especially in SoCal where it's all artificial turf.

My aim here is not to insinuate that you need to be growing an entire cocktail garden (complete with clucky little egg vending machines); rather, to encourage you to use seasonal, garden-fresh goodies whenever and however it's possible for you. If you don't have a garden to grow in, maybe you've got a small patio with room for a few pots, or a bright kitchen windowsill that you might grow some herbs on. But if you don't have any of that, or, if you just don't have the patience for it, hit those farmers' markets hard.

My recipes include a lot of from-scratch syrups and infusions that utilize a lot of said fresh ingredients. But there's a lot of store-bought cheats, as well. DIYing cocktails from garden to glass is great and all, but we're all busy people. Sometimes you just want to buy the damned juice, you know?

I also like to wrap myself up in a very particular, very cozy little blanket of delusion that everyone has chickens in their life. On some basic level, I under-stand this isn't true. But here's the beauty; you don't *need* to own them (*cough, cough* . . . be owned by them) to live the Drinking with Chickens life. Go forth into the world, my friends, and find chickens to drink with. They're out there; biodynamic vineyards and breweries, bars in Key West, Florida, every beach on every island in the entirety of Hawaii; even a gorgeous little restaurant in the middle of an industrial warehouse in downtown LA. And really, chickens are only a place holder; I want you to happy hour with what you've got, whether it's dogs, alpacas, parakeets, actual human people friends, or a random giant chicken statue in the middle of nowhere. You do *you*. *Drinking with Chickens* is about (**responsibly*) living your very best happy hour life, no matter where you are and who you're with.

The Disclaimer Chapter

THE FUN POLICE

Here's the dirty truth about chickens: they are filthy animals. Filthy, filthy, adorable, filthy animals that have zero personal boundaries. And you really can catch all sorts of properly horrifying cooties from them. So, to be frank, they have absolutely no business being anywhere near your cocktail, your food/drink surfaces, your hands, or your face. This book is meant purely for entertainment purposes; don't take it so damned literally.

I take a lot of creative liberties with the delivery of my "art" (*I just wanna do my art, Mom!!!*). I'll often show a chicken casually strolling by a showy little cocktail, or a single, graceful chicken claw reaching out to fondle a piece of

garnish. These are props. It's chicken satire, people. If you turn your back on your drink with chickens around, they will sidle up to it and either gobble your garnish in one hot second, roundhouse-kick the entire glass to the ground, or just stand there awkwardly touching it with their fluffy chicken butt like it's a paying job. No matter what sort of contact, any cocktail that has been compromised by a chicken should not, under any circumstances, be consumed. Heed my elaborately staged and pointlessly pretty warning photos. Do not let your chicken chill next to a drink that you are actually putting into your face.

Above all else, always prioritize safe sanitation practices, both during happy hour and with chicken keeping, in general. Aggressively sanitize all surfaces, and wash your hands, wash your hands, wash your damned hands. And don't dial it in; sing the *entire* "Happy Birthday" song while you lather, okay?

The kind of "drinking with chickens" I'm happily encouraging here, though, is the sort that involves limited chance of chicken-cocktail entanglement. It's the low-impact variety that requires you to be sitting (or, if you're an overachiever, standing) with a drink, while bearing witness to the glory of your ridiculous birds chickening around the yard. From afar. Guard that beautiful booze with a really solid defensive zone.

BIRDS + BOOZE = NO

Additionally (and I really, really, really wish I didn't have to say this), please do not give your birds, or any animal, alcohol. It is terrible for them, and it is not funny. At all. Drink all the booze (*responsibly*) yourself. Do it for the chickens. *Do it for the chickens.*

Furthermore, do not *ever* leave your cocktail unattended in the presence of poultry. They are ninjas and will descend upon it before you have time to actually blink, compromising not only the safe drinkability of your booze, but probably also helping themselves. So, guard it with your life.

BEING MINDFUL OF YOUR INGREDIENTS

Oh yes. There are plenty of other things to worry about besides unscrupulous livestock.

Raw Egg

I'm a big fan of raw eggs in cocktails. They add a lovely layer of texture and flavor to many different types of drinks, and egg cocktails usually look pretty dang gorgeous, as well. Clearly, I also have a tendency to use them because I am muchly overwhelmed with fresh eggs on a daily basis. Because let's be really honest: what the hell else am I going to do with them?

Raw eggs do come, however, with their own set of cautions because they can definitely get you sick. It goes without saying that the very young, the very old, the pregnant, and the immunocompromised should avoid consuming raw egg. They should also . . . yanno . . . not be consuming alcoholic beverages from this book. For the rest of us, putting raw egg in our face holes must be done with a healthy dose of caution. Use only the very freshest eggs, plus common sense (*Gasp! What's that?!*). Use the float test to check the freshness of even store-bought eggs: drop each egg in a glass of water and if it sinks and lays flat on the bottom, it's fresh as a daisy. If one end floats up and one stays on the bottom, it's edible only if fully cooked. If the whole thing floats, it's gone bad. Furthermore, once you crack it, if it smells or looks funny, it's best to scrap it. For those who are extra leery, buying pasteurized eggs is definitely an option (and let's just emphasize here that "pasteurized" does NOT mean the same thing as "pasture-raised" . . . *ahem*). And for those who are extra, extra leery of raw egg or avoiding animal products, you can substitute a lovely little thing called aquafaba (the liquid from a can of garbanzo beans . . . Yup, you read that right) in a recipe that calls for egg white. One tablespoon of aquafaba equals 1 large egg yolk, 2 tablespoons of it equal roughly 1 large egg white, and, you guessed it with your nimble mathematical acuity: 3 tablespoons equals 1 whole egg.

Garden Fresh

Harvesting fresh ingredients from your garden is all fun and games until you unwittingly grab the wrong thing and wind up in kidney failure. Sorry to be dramatic, but it's true. If you don't know with absolute certainty that what you are gathering is safe to consume, do not use it. Period. Also, don't feed it to your chickens.

First, make sure that all garden ingredients are organic and have not been treated with pesticides or herbicides. Make damned certain. *Especially* if you have chickens. I will very often encourage the use of edible flowers as both garnishes and ingredients, but these are all materials I personally grow and maintain organically in my yard. Do not buy flowers off the stand at supermarkets to use in any consumable capacity unless they are certified organic/food safe.

Second, the world of edible flowers can be surprisingly disingenuous. Many popular edible flowers have both edible and nonedible varieties just to shake things up. And when I say "nonedible," in most cases, I mean "highly toxic." Jasmine and honeysuckle (though we don't use them in any of these recipes) are two such plants. Using them as an inedible decorative garnish is one thing, but if you are cooking or infusing with them, be dang sure you know your variety is the edible kind.

ALL THE

Fancy

AND NOT-SO-FANCY TOOLS

TOOLS, GLASSWARE, ICE, & GARNISH

Listen, I'm not a professionally trained bartender by any far-fetched stretch of the imagination. I don't even much like the term *home mixologist* (home chixologist? Anyone? *Anyone?*). What I am, however, is a really, really enthusiastic drinks enthusiast stumbling awkwardly through the craft cocktail ropes one beverage at a time. It ain't always pretty: there are a lot of mistakes, and a lot of cursing, and a lot of clumsy dropping of shakers and startling of adjacent poultry. But you know what? Proper equipment really helps. And while I'm not saying you need to have a complete arsenal of expensive barware and surgical craft cocktail instruments, *or* the full-fledged skill to use them properly, I *am* saying a few key items will make things a little easier, quicker, and hey! maybe more fun.

FANCY SHAKERS

Most of the recipes in this book rely on being shaken in a shaker, so I thought it prudent to discuss a little bit for those who aren't necessarily familiar with them. Several different styles of shakers are available, and they all have their positives and their negatives. Let's discuss:

The Cobbler: This is the one most readily available over the counter to the average consumer. It's easy to find, it's easy to understand, it has a built-in strainer, and frankly, even though I'm supposed to be this fancy home chixologist, it's the one I use most. The downside to them is that most are pretty cheaply made and when they get chilled (which is basically the point of their very existence), the air inside creates a vacuum that can sometimes make it very difficult to open up after you've been shaking a drink in them.

The Boston Shaker: This is the kind you'll likely see professionals using behind the bar because it's versatile and can be used to both shake and stir cocktails. It's a simple, two-piece contraption consisting of a mixing glass and a metal tin. There are also fully metal versions. You'll need an auxiliary strainer to fit over it to strain liquids.

The Boston shaker can be a little daunting for those of us new to cocktail making; you've got to pop the mixing glass and the tin together just so to create that perfect seal (cue: repeated scenes of me shaking and margarita liquids spraying everywhere), and likewise, once you have that seal and have finished shaking, you've got to break that seal with an expertly aligned spank. And if you don't hit it just right, you stand there spanking your shaker over and over and it gets a little awkward. It all just takes a bit of practice to get right.

The Mason Jar: I mean, why the hell not? There are actually pretty fancy little cobbler-type shaker lids you can get for them these days, but honestly, you can even shake a cocktail with just the normal screw-on jar lid. You'll need to slap a strainer on that sucker to strain your beverage out, but overall, I feel like it's a pretty nifty way to shake up a drink. The downside? If you're like me, and you're prone to dropping things: glass.

OTHER COCKTAILY TOOLS

Strainers: There are a few different styles, but for the purposes of this book, we're only going to care about the Hawthorne strainer and the fine-mesh strainer. The Hawthorne is the typical style of cocktail strainer that you'll usually see bartenders using; you'll need one for your Boston shaker and also your mason jar shaker. They adapt nicely to a variety of different sized containers, and they strain fast. The problem with the Hawthorne strainer is that it doesn't strain on a superfine level, but never fear: the fine-mesh strainer is here. To get a supersmooth cocktail, strain with a Hawthorne into a fine-mesh strainer. I also use them to strain all my small-batch syrups and diffusions.

Jigger: These cute little measuring vessels come in a variety of sizes, shapes, materials, and styles. I mean, you *could* measure stuff with your giant plastic 2-cup kitchen measuring cup, but it's a little needlessly bulky.

Cocktail Muddler: I definitely suggest you have a muddler. If you're using all these fresh ingredients that I'm pressuring you to, you're going to need to muddle some stuff. They also come in a variety of shapes, sizes, and materials, so pick whatever floats your goat.

Bar Spoon: It's a spoon. That you use for bar things. Technically, you could get away with using just a normal spoon, but the long, delicate handle makes stirring a little more efficient, and the tiny spoon at its end is a great measuring tool for small ingredient quantities.

THE COBBLER

FANCY GLASSWARE

If you're happy drinking out of a souvenir plastic cup that you got back in your Trashcan Punch days of college, *you do you*. I ain't even about to judge (cough, cough . . . *drinks with poultry*). So if you don't care about all the various glassware, just go ahead and skip this part. I still love you. Actually, if you are truly still dedicated to drinking out of your Trashcan Punch cup, I kind of love you more now.

Rocks Glass (a.k.a. Old-Fashioned Glass, Lowball Glass, Tumbler): You'll see me use this one *a lot*. It's pretty versatile, and if you have absolutely no cocktail glasses and wanted to get just one, I'd probably tell you to get this one. They come in a standard size, which holds 6 to 10 ounces of liquids, and also in a double size, which holds more like 12 to 16. You can put your margaritas in them, your mai tais, your sours, your old-fashioneds: TRUE STORY. You can get away with putting a lot of stuff in a rocks glass.

THE BOSTON SHAKER

THE MASON JAR

STRAINER, JIGGER, MUDDLER, BAR SPOON

Collins Glass/Highball Glass/Delmonico Glass: These are all technically different shaped tall glasses made for different types of tall drinks, but unless you are super particular, they're all fairly interchangeable. You'll use these for your Tom Collinses, your Mojitos, your gin and tonics: drinks that take a lot of ice and a lot of mixer.

Coupe: Well, ladies and gentlemen, this is my favorite glass. I abuse it. Just like the rocks glass, it's pretty damned versatile, and also pretty damned pretty. Use it for Champagne and Champagne cocktails, but also use it for a myriad of mixed drinks: Daiquiris, sours, martinis, Manhattans, margaritas—am I repeating myself? Yes. Many of these cocktails can go in different glasses. They are equal opportunity.

Flute: Interchangeable with the coupe for your Champagne, sparkling wine, and sparkling wine–based cocktails. But less spilly.

Wine Goblet/Wine Glass: Obvi, you put your wine in it. But these can be great for wine-based cocktails; things like sangria. And also sangria.

Pint Glass/Pilsner Glass/Weizen Glass: Things for putting your beer in. And your beer cocktails. And sometimes, other random cocktails.

Punch Cup/Eggnog Glass: You know . . . the little mug thing that comes in the set when you buy a punchbowl.

Irish Coffee Glass/Hot Toddy Mug: These are for your hot booze situations. These clear, graceful mugs are like the elevated version of the mug you drink your coffee out of every morning that you won in the office raffle. You know, the one that says "There May Be Whiskey in This," in dishwasher-weathered Comic Sans.

Tiki Mug: Do I really need to explain this? It's where your ridiculous tiki garnish is going to hang out.

Copper Moscow Mule Mug: I get a little itchy about these mugs. Because they are only good for one kind of drink (although you can do juleps, or Greyhounds, or really anything you damned well please in them), let's call a spade a spade: if you see one of these mugs coming at you, you're expecting a Moscow Mule. End of story.

Mint Julep Cup: Although we don't technically have a julep recipe in this book, I suggest its use at least once. It's kind of interchangeable with the Moscow Mule mug, in my opinion.

Gin Balloon: A ridiculously glorious goblet to sip your gin and tonic from while you pretend that you're fancy. The wide-open style of the vessel helps the gin to loosen up, while the slender stem encourages your pinkie finger to take the full upright locked position.

Martini Glass: Don't even mention these in my presence. I do not possess the coordination to drink from one without sending three quarters of my beverage down my shirt. I'm still convinced this glass was designed as a joke (and the haziness of its actual origins further fuels my theory that it was forged in the bowels of hell). I understand that the wide brim is better for the gin, blah blah, yadda yadda, but *Not today, Satan.* If I martini, I put it in a coupe.

ROCKS GLASS

COLLINS GLASS

COUPE

FLUTE

WINE GLASS

PINT GLASS

PUNCH CUP

IRISH COFFEE GLASS

TIKI MUG

COPPER MOSCOW MULE MUG

MINT JULEP CUP

GIN BALLOON

MARTINI GLASS

FANCY ICE

Oh, ice. Its clarity and shape inspire much heated debate throughout the cocktail world; so many damned *feelings* over a little hunk of cold water. At one end of the ice spectrum, you have basic refrigerator ice: the kind that your fridge barfs out all day long. It's cloudy, it's awkwardly shaped, and it hints of plastic and electronics on the nose. But, hey! It gets your beverage cold! On the other end of the spectrum, there is that really ridiculous artisan ice. The kind that is so clear that you put it in a drink and it visually disappears. Seriously, what is that stuff made from? Moonlit mountain stream water collected by virgins, then filtered through diamonds?

I fall somewhere in the middle of these two extremes. Which is, I believe, the realistic camp for most people to hunker down in; those who care a little about how clear their ice is, but aren't going to dedicate themselves to being able to read newsprint through it. And frankly? I like to *see* my ice in a drink: it adds visual texture to the overall presentation (in my nonprofessional opinion). It just doesn't need to be chalk white.

I should note that there are some pretty cool gadgets out there on the market now that will help you easily make clear ice at home. I just don't have any of them.

So, here's how I make mine: You start with distilled water, then you boil it. Then, you let it cool. Then, you boil it again. Then, you cool it again. And you know what? I do this a third time because: third time's a charm (it's science). Why does boiling your water make clearer ice? Because the opacity in ice is really just tiny trapped air bubbles and impurities, and boiling the water releases some of these.

When your thrice-boiled water has cooled, place it in ice trays or molds and freeze it. It'll probably still have some vague cloudiness to it in spots, but for the most part will be clear. As I said before, that *little bit* of opacity actually helps the ice be visible in a drink. So, I'm not mad at it.

I use crushed ice in a lot of my recipes. You can crush it by hand (some great ice-crushing kits are to be had online), get yourself a fancy countertop ice machine, or just use the crushed ice option from your fridge. I do that. For some reason, I like how the white fridge ice looks in a cocktail when it's crushed into tiny pieces. Haters gonna hate.

Shaved ice is another way of fancying up your ice. You'll need either a hand-cranked shaved ice maker, or a spiffy electric one. Or just used crushed ice from the fridge. Who really cares.

You'll see me use flavored ice in some of my recipes, as well. Ice made from frozen juice, or filled with pretty things like flowers, fruits, and spices. It's just another creative opportunity to up the visual appeal of your beverage.

Which brings us to garnish.

OBNOXIOUSLY FANCY GARNISH

Yet another rather polarizing topic in Cocktailville (these are *very important* issues, people) is garnish. If you flip through the pages of this book, you will see that I am, indeed, rather fond of garnish. I like it a lot. When all else fails, I will, at the very least, throw a charming edible bloom on the top of my drink because it's *charming*. And I have no remorse that it serves absolutely zero function other than that it's pretty to look at. But oftentimes, garnish is actually a legitimate part of the experience of consuming the drink. The fragrance of a garnish can add a whole different level/layer to the flavors of a beverage.

But . . . if you leave the garnish out, will the poles reverse? No. The garnish suggestions on each recipe are just that: suggestions. You can skip them. You'll break my little drinking-with-chickens heart, but you can omit them. Just promise me this: don't skip the garnish on a tiki drink, okay? There's only so much I can take.

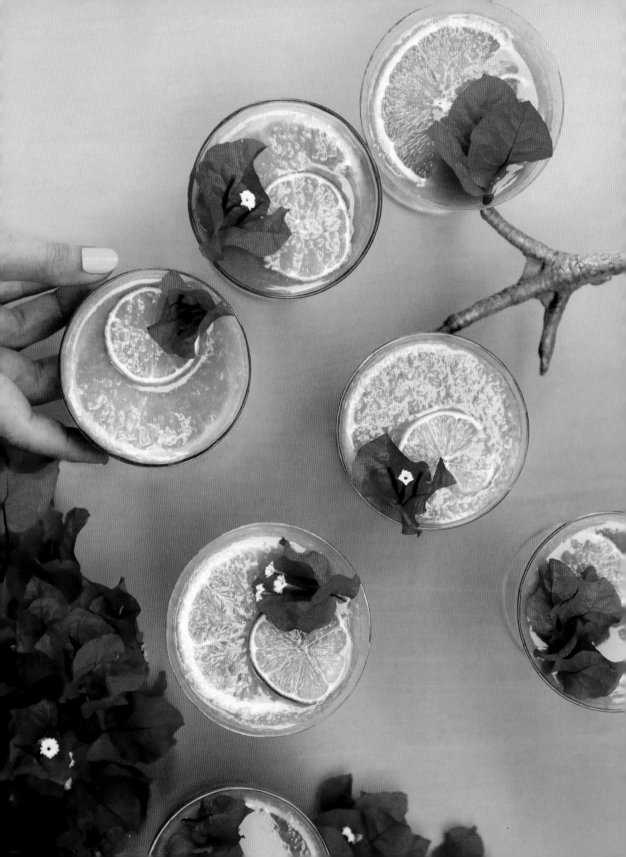

Dazed &
Infused

Here's a handy little collection of all the booze infusions you'll need for the cocktails in this book. But, in case you don't *quite* have the patience to sit and stare at jars of alcohol for days on end, I've included shortcuts (where applicable) in every recipe that wants to be infused. In summation: you can be sophisticated and plan for a cocktail weeks in advance, letting your booze marinate in some lovely seasonal ingredients, or also you can just . . . not.

APRICOT-INFUSED RUM

½ cup light rum

½ cup diced fresh apricots (or ¼ cup un-
sweetened, dried)

Makes ½ cup. • Combine ingredients in an air-
tight container (I very much prefer a mason jar).
• Store it in a cool, dark place for a week, shaking
it from time to time. • Strain the liquid and place
it back in the airtight container. • Store indefi-
nitely.

PINK PEPPERCORN VODKA

1 tablespoon pink peppercorns

1¾ cups vodka

Makes 1¾ cups. • Place ingredients in an airtight
container, seal, and store in cool, dark place for a
week. • Strain peppercorns from the vodka, and
return the spirit to its airtight container. • Then,
stick it in the freezer. It's vodka. It goes in the
freezer.

ORANGE PEEL WHISKEY

¾ cup whiskey

Peel of 1 medium-size orange
 (white pith removed)

Makes ¾ cup. • Place all ingredients in an airtight container, seal, and store in a cool, dark place for a week, agitating mixture once a day. • Strain liquid, reseal in airtight container, and store indefinitely.

SALTED RADISH VODKA

2 cups plain vodka

6 halved radishes (I use the standard
 red variety, which lend a lovely
 pink hue to the spirit, but any
 variety will work)

1 teaspoon Himalayan sea salt

Makes 2 cups. • Combine all ingredients in an airtight container, seal, and store in a cool, dark location for a week, shaking occasionally. • After a week, strain solids from liquid, reseal, and store in the freezer indefinitely.

ROSEMARY-INFUSED GIN

2 sprigs fresh, organic rosemary
 (4 to 5 inches in length)
2 cups gin

Makes 2 cups. • Give the rosemary a good smack between your palms to release the oils. Don't be shy. Remove rosemary leaves from stems. • Place gin and rosemary leaves in an airtight container, seal, and store in a cool, dark place for 3 days, agitating infusion periodically. • Strain rosemary leaves from gin and discard them, seal gin back up, and store indefinitely.

HABANERO-INFUSED TEQUILA

1 cup silver tequila
1 habanero pepper, stemmed and
 sliced in half lengthwise

Makes 1 cup. • Place tequila and pepper in an airtight container and store overnight in a cool, dark place, agitating once or twice. • Strain pepper from liquid and store in airtight container indefinitely.

SPICY TOMATO-INFUSED VODKA

2 cups vodka
6 cherry tomatoes, sliced in half
½ jalapeño pepper

Makes 2 cups. • Place all ingredients in an airtight jar, seal, and store in a cool, dark place for about 5 days, shaking the mixture about once a day. • Strain away solids and store infused vodka in an airtight container indefinitely.

PINE NEEDLE–INFUSED GIN

¼ cup loosely packed organic
 pine needles, cut into approximately
 1-inch sections
¾ cup gin

Makes ¾ cup. • Place pine needles in the bottom of an airtight container and muddle aggressively. • Add gin, seal, and store in a cool, dark place, for a week, shaking every so often. • Strain needles from gin, replace gin into airtight container, seal, and store indefinitely.

CELERY-INFUSED VODKA

2 cups plain vodka
1 cup chopped young leafy celery

Makes 2 cups. • Place all ingredients in an airtight container and store in a cool, dark place for a week, agitating every day or so. • Strain away solids, replace liquid into airtight container, and store indefinitely.

CHAPTER 1

Spring

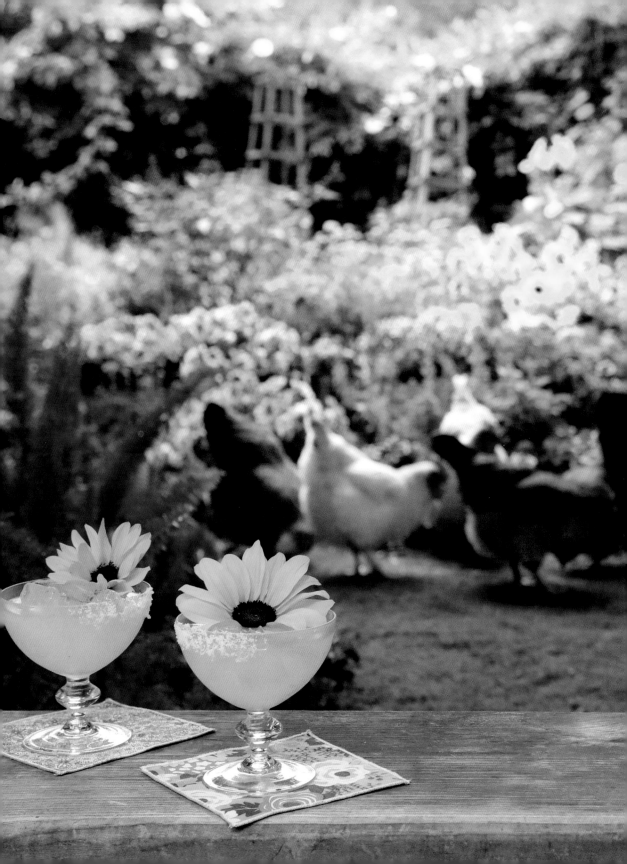

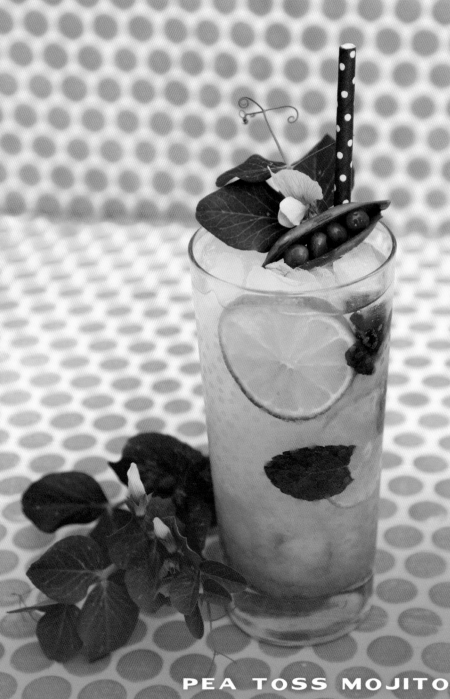

PEA TOSS MOJITO

(ON PAGE 50)

LILAC APRICOT RUM SOUR

· MAKES 1 SERVING ·
GLASS SUGGESTION: COUPE OR FLUTE

Lilac is one of those scents that I get overly clingy about when I encounter it in the wild. I want to sniff it, I want to bathe in it, and yes, I want to drink it, okay? But not, maybe . . . in that order. So, naturally, I want to put it in a pretty little cocktail. The best way to go about this is to either cook it down into a simple syrup, or infuse it in a spirit (or *both*. Don't get stingy on me now!). For the purposes of this cocktail, we'll be doing a syrup. And then, of course, don't forget to garnish the living daylights out of your drink with fresh lilac.

6 organic lilac blossoms to crush
 against the glass and scent it
2½ ounces Apricot-Infused
 Rum (page 26)
¾ ounce Lilac Blossom Syrup
½ ounce freshly squeezed lemon juice
1 medium-size egg white
GARNISH: Several organic lilac blossoms

• Use a few lilac blooms to rub the rim of a coupe glass. Gotta mark your territory. • Next, add ice, Apricot-Infused Rum, Lilac Blossom Syrup, and lemon juice. • Shake until chilled. • Strain the cocktail mixture into another glass, discarding ice from shaker, pour the cocktail mix back into the shaker, and add egg white. • Shake thoroughly for around 30 seconds. • Pour cocktail (don't strain) into prepared coupe glass and garnish with fresh lilac blooms.

LILAC BLOSSOM SYRUP

½ cup granulated sugar
½ cup water
1 cup fresh lilac blossoms, stems and all
 green bits removed

Makes ½ cup. • In a small saucepan over medium heat, combine sugar and water and bring to a slow boil, stirring occasionally until sugar is dissolved. • Add lilac blossoms, stir to cover, and lower heat to simmer for 3 minutes. • Remove from heat, cover, and allow to steep for several hours. • Strain liquids into an airtight container and store in fridge for up to 2 weeks.

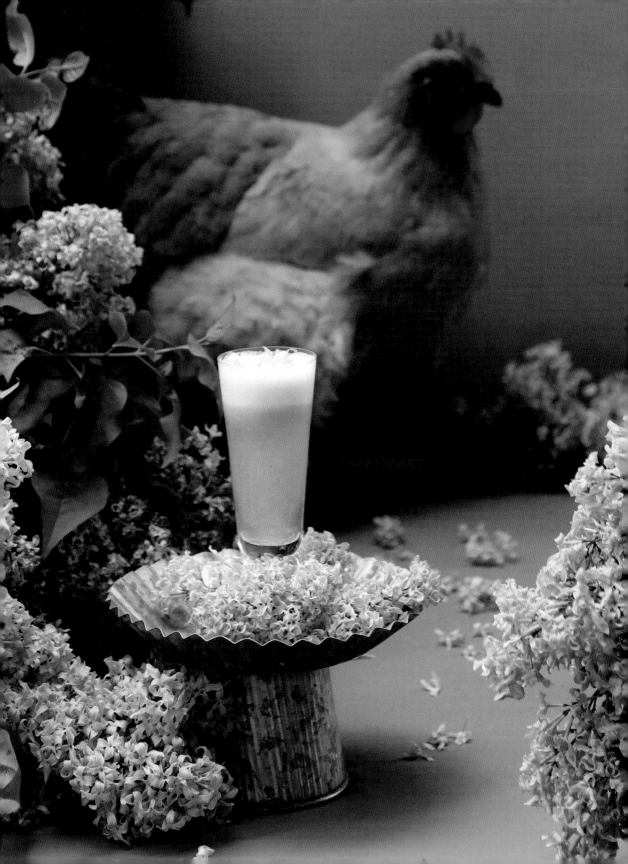

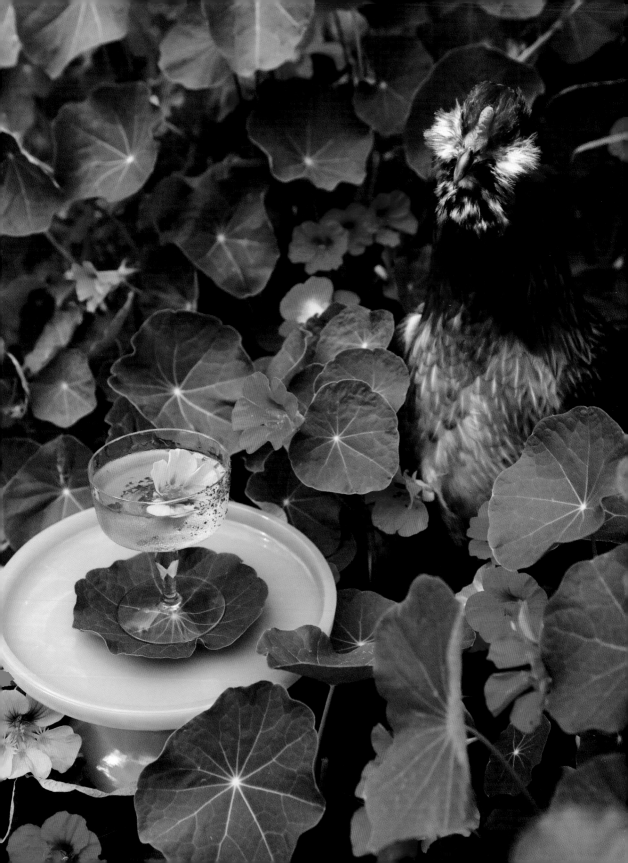

NASTURTIUM + PINK PEPPERCORN VESPER

· MAKES 1 SERVING ·

GLASS SUGGESTION: COUPE

Let's be classy and mysterious and drink Vespers like James Bond, shall we? But instead of the traditional 3 parts gin, 1 part vodka, ½ part dry wine aperitif, and twist of lemon, I'm going to go ahead and bastardize it by putting in some weeds from my garden. Because I can. This brings me to nasturtiums. Maybe you don't see nasturtiums and immediately think: cocktail. But I do. *I do.* Both the leaves and the blooms have a light, tangy, peppery flavor (which makes them a great salad addition, too), and dang do they look purty floating in some booze. Pro tip: oversize nasturtium leaves make adorable drink coasters. Another pro tip: don't roll your eyes at me.

Lemon slice and ¼ teaspoon crushed
 pink peppercorn for rimming glass
2 organic nasturtium blossoms
3 ounces gin
1 ounce chilled Pink Peppercorn
 Vodka (page 26)
½ ounce Lillet Blanc (or other white
 wine aperitif)
GARNISH: 1 organic nasturtium blossom

• Prep your coupe glass: Take a lemon slice and rub it along the edge of your glass, then dip the juiced edge of the glass into a dish of crushed peppercorns. You can rim it all along the edge (à la chain restaurant margarita salt style), or do something like a 1 by 1-inch swatch (which I prefer because you can selectively put your face on it, as opposed to having the pepper be in every single sip). • Next, place 2 nasturtium blossoms and ice in a shaker. • Add gin, Pink Peppercorn Vodka, and Lillet. • Shake until chilled. • Strain shaker contents into your prepared glass, then float a nasturtium blossom as garnish. • Sit in your garden and watch the chickens chickening through the nasturtiums. Relax for 5 minutes, or as long as it takes you to realize that they have decimated them, and this will be your only nasturtium cocktail for the year.

APPLE BLOSSOM MAI TAI

· MAKES 1 SERVING ·

GLASS SUGGESTION: CHILLED ROCKS GLASS

You don't need actual apple blossoms for this cocktail, although if you happen to have them, they make for a pretty stunning garnish. Because sometimes your cranky apple tree decides that the very spring you happen to be shooting a cocktail book, it's gonna just . . . not do blossoms. So, you use cherry blossoms and pretend. This cocktail is named and inspired by my rather dramatic love/hate relationship with said apple tree.

So, let's make us a beverage in honor of those three, maybe four, maybe zero apple blossoms that I get every year, and let's make it a mai tai because, as you will see, I am obsessed with them and find a seasonal way to drink them all year long.

1½ ounces aged rum

1 ounce freshly squeezed lime juice

½ ounce elderflower liqueur, such as St-Germain

½ ounce Apple Orgeat Syrup

3 drops aromatic bitters

½ ounce dark rum float

GARNISH: organic apple blossoms, if you got 'em, or apple slices or a lime wheel

• In a cocktail shaker, combine aged rum, lime juice, elderflower liqueur, Apple Orgeat Syrup, and aromatic bitters over ice and shake until chilled. Make a really determined "shake face" while you do it, or else it doesn't count and you have to start over. • Strain contents into a chilled rocks glass filled with ice. • Pour dark rum over the back of a spoon to "float" it over the top of the drink. • Garnish with apple blossoms or other edible blossoms, or with apples slices or lime wheel. Or don't garnish it at all. I don't care.

APPLE ORGEAT SYRUP

½ cup unsweetened, unflavored almond milk

½ cup granulated sugar

1 apple such as Pink Lady, cored and diced

Makes ½ cup. • In a small saucepan over medium-high heat, combine almond milk, sugar, and apple. • Bring to a simmer and heat, stirring occasionally, until sugar is full dissolved, 3 to 5 minutes. • Remove from heat. • Allow mixture to cool thoroughly, then strain into an airtight container and store in fridge for up to 2 weeks.

MEYER LEMON + ROSE-MARY OLD-FASHIONED

· MAKES 1 SERVING ·

GLASS SUGGESTION: ROCKS, LOWBALL, OLD-FASHIONED GLASS

The old-fashioned is one of those very polarizing drinks; you are either very particular about how yours is made and will accept no substitutions (or you'll accept a substitution but glare over the rim of the glass as you drink it), or you just . . . don't really care. Or you've never had one at all, and in that case: allow me to introduce you to my rogue version. Potentially, about a dozen people will get really mad about how it should be bourbon + sugar cube + bitters + citrus. Maybe a cherry thrown in for good measure. Meyer lemon? Rosemary? Who even let me in here? For this little guy, we're going to substitute a Meyer Lemon–Rosemary Simple Syrup for the sugar cube element, and instead of traditional aromatic bitters, we're doing citrus bitters (lemon, orange, grapefruit, or a mix of these).

Lemon peel for rubbing glass

Rosemary sprig for rubbing glass

2 teaspoons Meyer Lemon–
 Rosemary Simple Syrup

3 drops citrus bitters

2 ounces rye whiskey

GARNISH: 1 rosemary sprig +
 lemon peel for garnish

• Prepare your glass by rubbing the rim with your lemon peel. • Give the rosemary sprig a good smack (to release its oils; also, it's been naughty), then rub it along the outside edge of your glass. • Place Meyer Lemon–Rosemary Simple Syrup in the bottom of the glass, and add bitters to it. • Place a single large ice cube in your glass, then add rye whiskey. • Give the whole thing a stir, and then garnish with a rosemary sprig and piece of lemon peel.

MEYER LEMON–ROSEMARY SIMPLE SYRUP

½ cup freshly squeezed Meyer
 lemon juice

½ cup granulated sugar

2 sprigs fresh rosemary (4 to 5
 inches long each)

Peeled zest of 1 lemon (pith removed)

Makes ¾ cup. • Place the Meyer lemon juice, sugar, and rosemary in a small saucepan over medium-high heat and bring just to a boil. • Lower the heat to a simmer and heat for about 10 minutes, or until syrup has thickened a tad. • Now add the lemon zest, then remove mixture from heat and let it cool. • Strain mixture into an airtight container and store in the fridge for up to 2 weeks.

FENNEL MULE

· *MAKES 1 SERVING* ·

GLASS SUGGESTION: A CHILLED COPPER MUG. DUH.

Fennel? In a cocktail? Oh yes, my fronds (fennel puns). It might sound weird if you've never tried it, but trust me, it's a lovely flavor layer, whether it's infused, muddled, or syrup-ized. The funny thing about fennel, at least in my yard, is that I always have a lot of it planted, but I hardly ever get to actually use it. *Why?* you ask. Because my puppy loves to eat it. And that's an understatement. She hunts it down and inhales it (it is, in fact, very healthy for dogs, and also, very good for chickens, in case you're wondering . . . you probably weren't, but now you know).

¼ ounce absinthe

1 (¼-inch-thick) slice fennel bulb, chopped

½ ounce freshly squeezed lime juice

2 ounces vodka

6 ounces ginger beer

GARNISH: fennel fronds + lime wedge

• Pour the absinthe into the bottom of a chilled Moscow Mule mug and roll the liquid around the inside of the mug to thoroughly coat it. Discard any excess. • Add the fennel bulb bits and lime juice. • Muddle until fennel fragrance is released. • Add vodka. • Fill mug with crushed ice. • Top with ginger beer and garnish with fennel fronds and lime wedge.

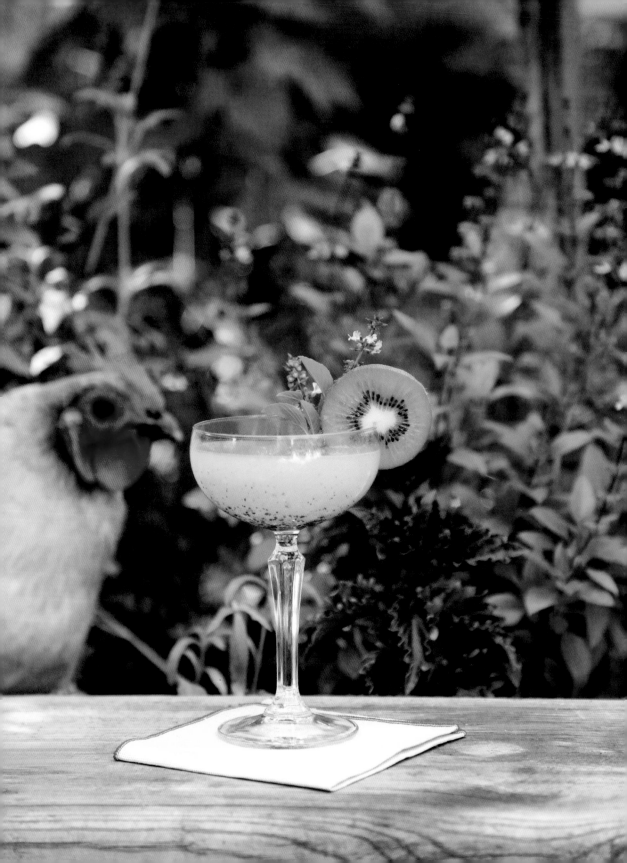

KIWI BASIL DAIQUIRI

· MAKES 1 SERVING ·

GLASS SUGGESTION: CHILLED COUPE

I really love a good, fresh daiq. We've been conditioned by chain restaurants to think a daiquiri is a sweet, frozen beverage almost always made with some syrupy store-bought mix of questionable provenance. It's usually served alongside its BFF, the blended margarita, and the only way you can really tell them apart is by what type of booze happened to land in it. I digress. The original daiquiri is a very simple shaken cocktail made with rum, simple syrup, and lime juice. So good, and so easy, and so good.

2 ounces light rum

½ ounce Sweet Basil Syrup

1 ounce Kiwi Purée

½ ounce freshly squeezed lime juice

GARNISH: 1 kiwi slice + 1 flowering
 basil sprig

• In a shaker over ice, combine all ingredients, except garnishes. • Shake until chilled, then strain into chilled coupe. • Garnish with kiwi slice and basil sprig.

SWEET BASIL SYRUP

½ cup fresh organic sweet basil leaves

½ cup water

½ cup granulated sugar

Makes ¾ cup. • Combine ingredients in a small saucepan over medium-high heat. • Bring just to a boil, then simmer for 5 minutes. • Remove from heat and set aside to cool. • Strain away leaves from mixture, store in an airtight container in the fridge for up to 2 weeks.

KIWI PURÉE

5 kiwis

Makes 1½ cups. • Skin and chop kiwis into approximately 1-inch cubes. • Place in blender or food processor and blend until smooth.

SAFFRON + CHAMOMILE SOUR

· *MAKES 1 SERVING* ·

GLASS SUGGESTION: TEACUP OR COUPE

If you don't grow saffron yourself, this can turn into a pretty pricey little drink. I show it garnished lavishly with dried saffron scattered like bourgie confetti across the top, but that's really not necessary to do (just make a simple syrup with it, as the recipe calls for). What *is* quite necessary is drinking this beverage with your pinkie up, since we're serving it in a teacup. Also, there's *actual* tea in it, so it works out nicely all around.

2 ounces Orange Peel Whiskey (page 27)

1 ounce freshly squeezed lemon juice

1 ounce brewed chamomile tea (prepared according to package instructions, then cooled)

½ ounce Saffron Syrup

1 medium egg white

GARNISH: 3 maraschino cherries, dried or fresh organic chamomile blossoms, and dried saffron, if you're feeling fancy

• In a cocktail shaker with ice, combine Orange Peel Whiskey, lemon juice, chamomile tea, and Saffron Syrup. • Shake until chilled. • Strain cocktail mixture into another glass, discarding the ice from shaker, pour the cocktail mixture back into the shaker, and add egg white. • Shake thoroughly for around 30 seconds. • Pour cocktail (don't strain) into cup of choice. • Garnish with a skewer of cherries, some chamomile blossoms, and maybe even some dried saffron.

SAFFRON SYRUP

½ cup granulated sugar

½ cup water

¼ teaspoon dried saffron

Makes ¾ cup. • In a small saucepan, bring sugar, water, and saffron to a boil over medium-high heat and heat until sugar is dissolved. • Remove from heat and let thoroughly cool. • Pour into an airtight container (don't strain) and store in the fridge for up to 2 weeks.

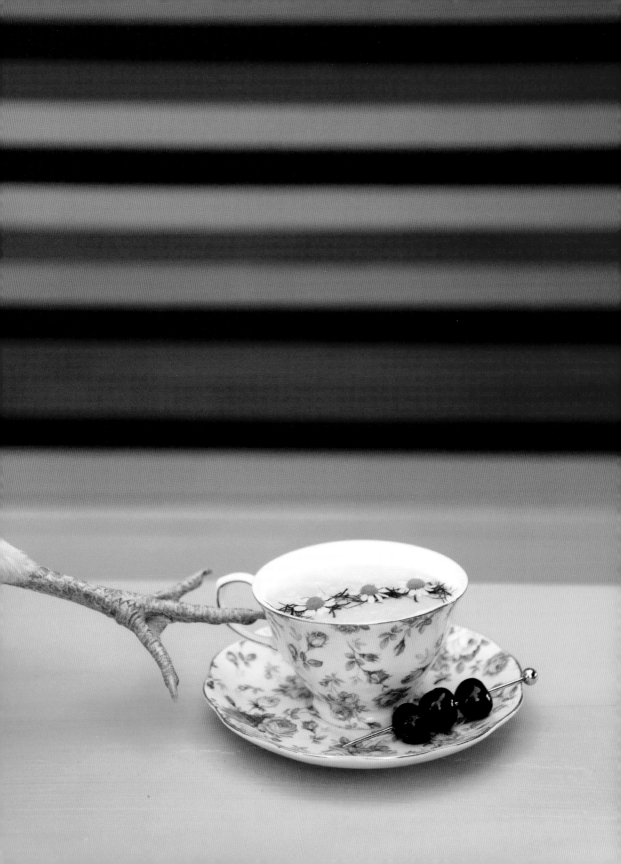

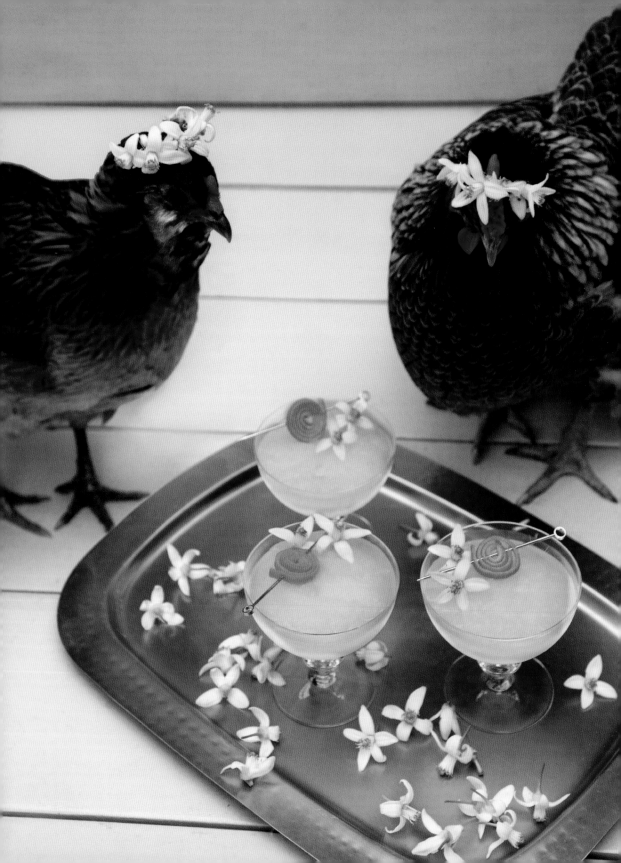

ORANGE BLOSSOM SLUSH

· MAKES 4 SERVINGS ·

GLASS SUGGESTION: CHILLED COUPE

Have you ever stood beneath a blossoming citrus tree, breathed in that heady fragrance, and wished you could bottle it up? We're going to do that and mix it with some frozy (yes, I said frozy) white wine. Do you have to have *actual* orange blossoms to make this cocktail? Nope. Not in the slightest. Is it extra cool if you have them and use them to make a glorious simple syrup? Why, yes; yes, it is. But you will get by just fine without.

1½ (750-ml) bottles dry white wine, such as sauvignon blanc, frozen in standard ice cube trays (fills about 3 trays)

½ (750-ml) bottle dry wine (the leftover from your 2 bottles), chilled

4 ounces Orange Blossom Syrup

2 ounces elderflower liqueur, such as St-Germain

GARNISH: organic citrus blossoms or other edible blooms

• Freeze the wine into cubes ahead of time, allowing at least 4 hours to fully freeze.

• Place wine ice cubes, chilled wine, Orange Blossom Syrup, and elderflower liqueur in a blender and blend until smooth. • Divvy up mixture among four chilled coupe glasses. • Garnish with orange blossoms or other edible blooms.

ORANGE BLOSSOM SYRUP

½ cup water

½ cup granulated sugar

⅓ cup organic orange (or other citrus) blossoms, petals only, or 1 tablespoon orange blossom water

Makes ¾ cup. • Combine water and sugar in a small saucepan over medium-high heat. • Bring just to a boil, lower heat, add either orange blossom petals or orange blossom water, and simmer for 5 minutes. • Remove from heat and set aside to cool. • Strain away petals from mixture (if applicable) and store in an airtight container in the fridge for up to 2 weeks.

PEA TOSS MOJITO

· MAKES 1 SERVING ·

GLASS SUGGESTION: CHILLED COLLINS GLASS

One of my favorite pastimes is what I refer to as the Great Pea Toss. It involves sitting in the garden, cocktail in hand (*Gasp! No! What?!*), a pile of peas, and the tossing of said peas, one at a time, to a cranky flock of chickens. Watching them chase single peas down like a pack of velociraptors is hours of entertainment. Like I said: a cocktail helps. Ladies and gentlemen: drinking with chickens. So, it makes sense that we would also toss a few peas in some booze, right? Right. A note about mint: I really, really, really want you to use either apple mint or pineapple mint for this, because they both have a sort of sweeter, mellower flavor profile. But I realize I'm probably the only crazy person that grows eleventy varieties of mint in their yard. Regular mint is fine. It's just fine. Everything is going to be just fine.

1 sugar cube for muddling

½ ounce freshly squeezed lime juice

6 apple mint or pineapple mint leaves
 (Substitute the variety of your choosing.
 No pressure. I swear.) for muddling

1 ounce Pea Purée

2 ounces light rum

Approximately 2 ounces plain or
 lime-flavored seltzer

GARNISH: 1 split pea pod + 1 organic
 pea tendril and blossom

• In the bottom of your chilled collins glass, place sugar cube and lime juice. • Muddle them into a puddle. • Now add the mint and muddle it, too, just until the leaves release their fragrance. • Add Pea Purée, then fill glass with ice. • Now add rum, and top off with seltzer. • Give the whole thing a solid stir, then garnish it with pea pod and tendril. Now, go throw your leftover peas at the chickens.

GOOD OL' PLAIN SIMPLE SYRUP

½ cup granulated sugar

½ cup water

Makes ¾ cup. • Combine both ingredients in a small saucepan over medium-high heat. • Bring to a boil and heat until sugar has completely dissolved. • Remove from heat and allow to cool. • Place in an airtight container and store in fridge for up to a month.

PEA PURÉE

¼ cup fresh or frozen and thawed peas

1 ounce freshly squeezed lime juice

½ ounce Good Ol' Plain Simple Syrup

5 dashes of orange blossom water

Makes ¼ cup. • Combine all ingredients in a blender or food processor and blend until smooth.

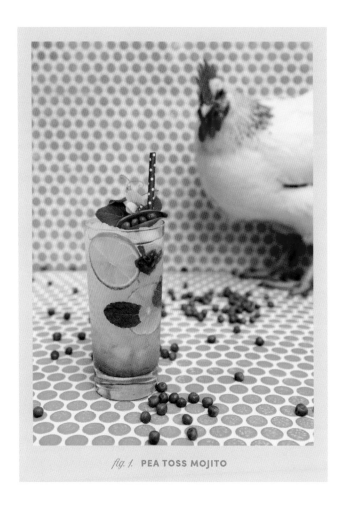

fig. 1. **PEA TOSS MOJITO**

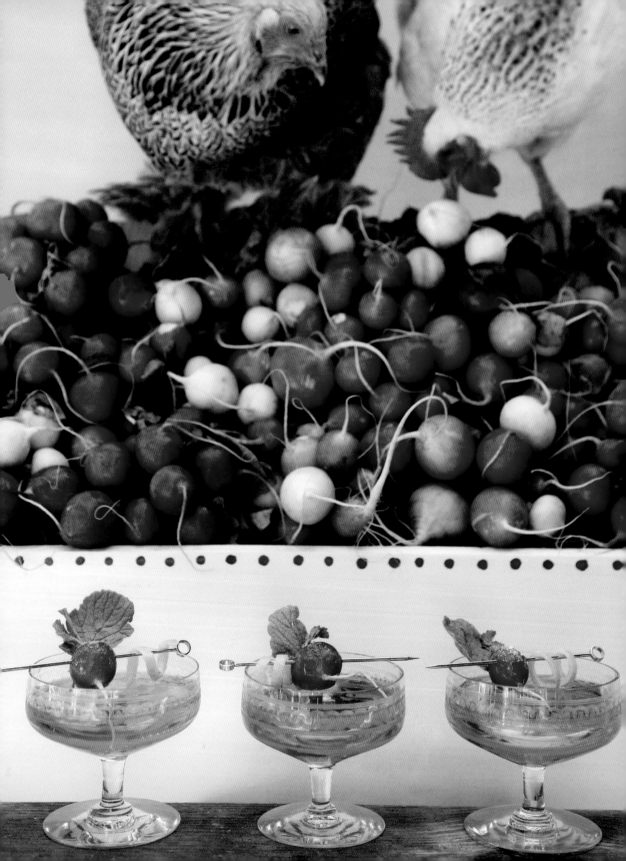

SALTED RADISH MARTINI

· MAKES 1 SERVING ·

GLASS SUGGESTION: CHILLED COUPE

All right, this one is probably a bit of a stretch for anyone who doesn't like radishes. I loooove radishes. Love them. Give me a plate of radishes and a pile of salt to dab them in any day of the week. But yes, radishes are rather . . . pungent. Especially when you soak them in alcohol. So, I repeat: you must really adore radishes to enjoy this cocktail. Have I scared you yet? Good. More radishes for me and the chickens.

If you want to skip the infusion process and have a slightly subtler radish flavor, muddle one finely chopped radish along with a pinch of salt in the bottom of your shaker. Once good and muddled, add 2 ounces of vodka to it and let it sit for 5 minutes or so before you add the other ingredients and shake.

1 lemon twist for rimming glass

2 ounces Salted Radish Vodka (page 27)

½ ounce chile-flavored vodka, such as St. George

½ ounce dry vermouth

GARNISH: 2 radish slices dipped in Himalayan sea salt (I used watermelon radish)

• Rub the rim of your chilled coupe glass with your lemon twist. • In a cocktail shaker with ice, combine both vodkas and the vermouth and shake until very chilled. • Pour into prepared coupe, and garnish with radish slices and your lemon twist.

THE JUNGLE CHICKEN

· MAKES 1 SERVING ·

GLASS SUGGESTION: LARGE COUPE OR GOBLET, OR DOUBLE THE RECIPE AND PUT IT IN SOME SORT OF CRAZY TIKI MUG

There is a lovely classic tiki cocktail called the Jungle Bird that consists more or less of dark rum, Campari, simple syrup, and lime and pineapple juices. So, obviously I had to do my own spin, and obviously it needed to include a nod to my poultry. Additionally, I decided to throw in some passion fruit, because they run rampant in my garden in early spring. A note about passion fruit: If you can't get your hands on fresh passion fruit, no worries! Use store-bought passion fruit juice, and skip the pulp in the recipe.

1½ ounces dark rum

1 ounce pineapple juice

½ ounce passion fruit juice

½ ounce freshly squeezed lime juice

½ ounce Campari

½ ounce Honey Syrup

½ passion fruit, pulp only

1 medium egg white

GARNISH: pineapple, passion fruit, organic tropical blooms, pretty much anything you can get your hands on to make a fantastical tiki garnish. Don't hold back.

• Combine rum, fruit juices, Campari, Honey Syrup, passion fruit pulp, and egg white in a shaker without ice. • Shake aggressively for about 20 seconds to foam up the egg white. • Add some ice to the shaker and continue to shake until chilled. • Strain cocktail into glass of choice and garnish the living daylights out of it.

HONEY SYRUP

½ cup honey

½ cup water

Makes 1 cup. • Combine honey and water in a saucepan over medium-high heat. • Bring just to a boil so that the honey thoroughly dissolves. • Remove from heat and allow to thoroughly cool. • Store in an airtight container in the fridge for up to 2 weeks.

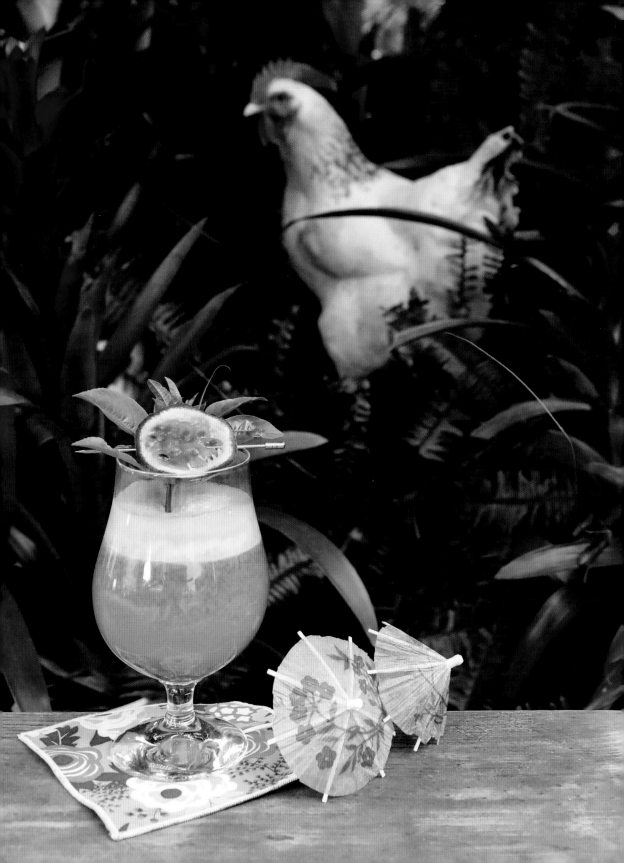

RHUBARB ROSE COBBLER

· *MAKES 1 SERVING* ·

GLASS SUGGESTION: COLLINS OR HIGHBALL GLASS

Rhubarb is just *so very good* in cocktails. It is the absolute goodest. Truth be told, I've struggled to grow it in my garden (mainly because I have limited places for it, due to the fact that the leaves are highly toxic and it must be grown out of reach of both feathered and furred pets), but I keep trying. Until I succeed (and believe me, victory shall be mine), I literally lie in wait, salivating, for it to appear at the farmers' markets in the spring.

3 orange slices

½ ounce Rhubarb-Rose Syrup

2 ounces dry rosé wine

1 ounce dry sherry

GARNISH: organic rose petals or
 blossom + rhubarb ribbon

• Prep your glass by filling with crushed or pellet ice. • In the bottom of a cocktail shaker, briefly muddle orange slices with Rhubarb-Rose Syrup. • Add ice, then rosé and sherry. • Shake until chilled. • Strain cocktail into prepped glass. • Garnish.

RHUBARB-ROSE SYRUP

2 cups chopped fresh rhubarb (stems only)

½ cup granulated sugar

½ cup water

1 tablespoon rose water

Makes approximately ¾ cups. • Combine rhubarb, sugar, and water in a small saucepan over medium-high heat and bring to a boil. • Heat just until sugar is dissolved. • Lower heat and simmer for about 15 minutes, stirring occasionally, until fruit is soft. • Turn off heat, add rose water, stir thoroughly, and allow to cool completely. • Strain, then store in an airtight container in the fridge for up to 2 weeks.

HONEYED PALOMA

· MAKES 1 SERVING ·

GLASS SUGGESTION: PINT, HIGHBALL, OR COLLINS GLASS

We are the very fortunate owners of a very, very old grapefruit tree that actually gives us *two harvests* a year. So, we are always up to our eyeballs in grapefruit. Thus, I make a lot of grapefruit cocktails. And give away a lot of grapefruit. And get hit in the head with a lot of falling grapefruit. Of note: citrus is not great for chickens; so no matter how they give you their grumpy little starving beggar faces, resist the urge to throw them the scraps.

1 tablespoon honey for rimming glass

1 tablespoon Tajín seasoning for
 rimming glass

2 ounces tequila

1½ ounces grapefruit juice

½ ounce freshly squeezed lime juice

½ ounce Honey Syrup (page 54)

2 ounces grapefruit-flavored or plain seltzer

GARNISH: 1 slice grapefruit

• Prep the glass: Spread the honey on a plate, and the Tajín on another plate. • Dip rim of cocktail glass first in the honey, then in the Tajín to coat. • Fill glass with ice.

• In a cocktail shaker with ice, combine tequila, grapefruit and lime juices, and Honey Syrup. • Shake until chilled, then strain mixture into prepared glass. • Top with your choice of seltzer, then garnish with grapefruit slice.

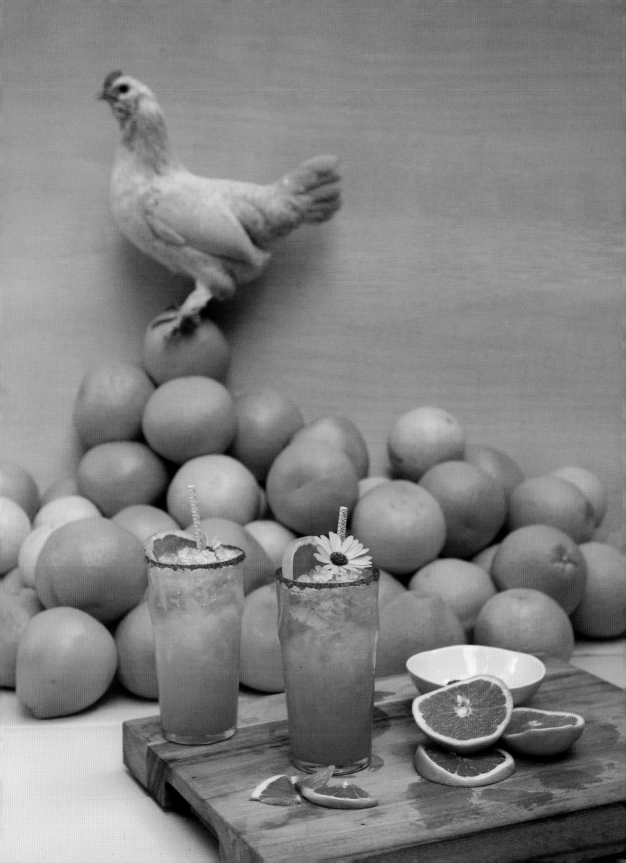

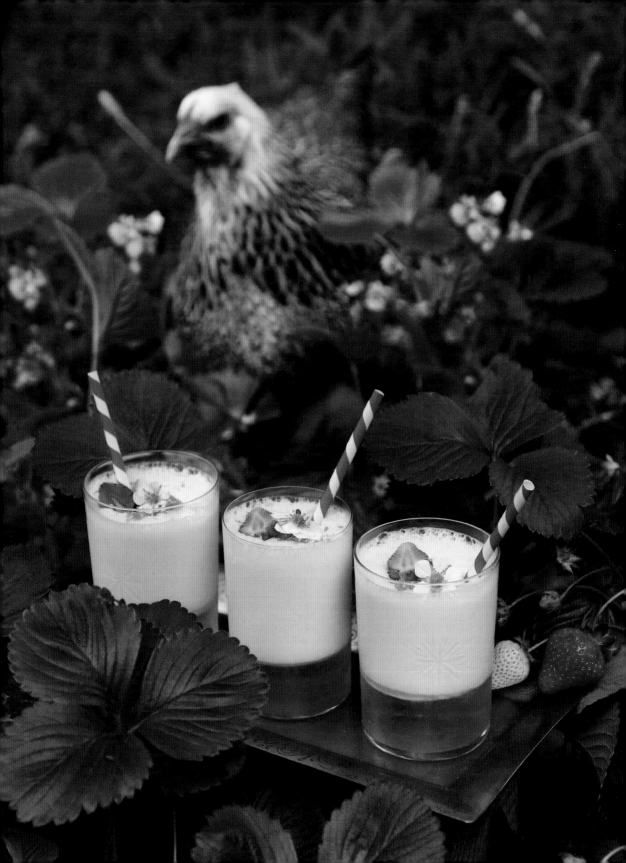

EARLY STRAWBERRY SYLLABUB

· MAKES 6 SERVINGS ·

GLASS SUGGESTION: LOWBALL OR ROCKS GLASS, OR COUPE

I have a bit of a thing for historical cocktails; if you haven't picked up on that already, you will. Back in ye olden times, when there was no refrigeration, dairy and eggs were a precious commodity that obviously spoiled fast. So, what did those intrepid colonial-era mixologists do? Why, they mixed in booze to preserve said perishable foodstuffs. This was considered "healthy" back then. Syllabub was one such healthy drink (and also, depending on how it is made, a type of dessert. Probably also considered a healthy dessert). I've taken some liberties with this recipe, such as using rosé wine and rum as the base spirit (our colonial-era ~~forefathers~~ forepeople lived the rosé life, didn't they? I'm pretty sure they did.), but the basic concept is the same: a boozy, creamy dessert cocktail that magically separates into pretty little layers in your glass. This is kind of an old-timey party recipe, so I'm batching it for you and your five closest friends.

½ cup granulated sugar

1 teaspoon freshly grated orange zest

½ cup Orange-Strawberry Syrup

¼ cup freshly squeezed lemon juice

¼ cup freshly squeezed orange juice

2 ounces light rum

2 cups dry rosé wine

2 cups heavy whipping cream

GARNISH: freshly grated orange zest + small strawberry + organic strawberry blossom

• Place the sugar and orange zest in a medium mixing bowl, combine. • Add Orange-Strawberry Syrup, lemon and orange juices, wine, and rum and stir until combined. • Add cream to mixture, and with an electric mixer, whip until cream is foamy on top. • Carefully pour mixture into 6 glasses, then let the glasses sit, covered, for 1 to 2 hours at room temperature to separate. • Transfer glasses to fridge to cool. These can be prepared up to 24 hours in advance. • Just before serving, dust with orange zest and garnish with strawberry and blossom.

RECIPE CONTINUES ›

ORANGE-STRAWBERRY SYRUP

½ cup granulated sugar

½ cup water

4 ripe strawberries, hulled, chopped,
 and mashed

1 teaspoon freshly grated orange zest

Makes ½ cup. • In a small saucepan, bring sugar and water to a quick boil and heat until sugar is dissolved. • Lower heat to simmer, then add strawberries and orange zest. • Simmer for 10 minutes, stirring occasionally. • Remove from heat, let cool thoroughly, and strain away the solids. • Place in an airtight container and store in fridge for up to 2 weeks.

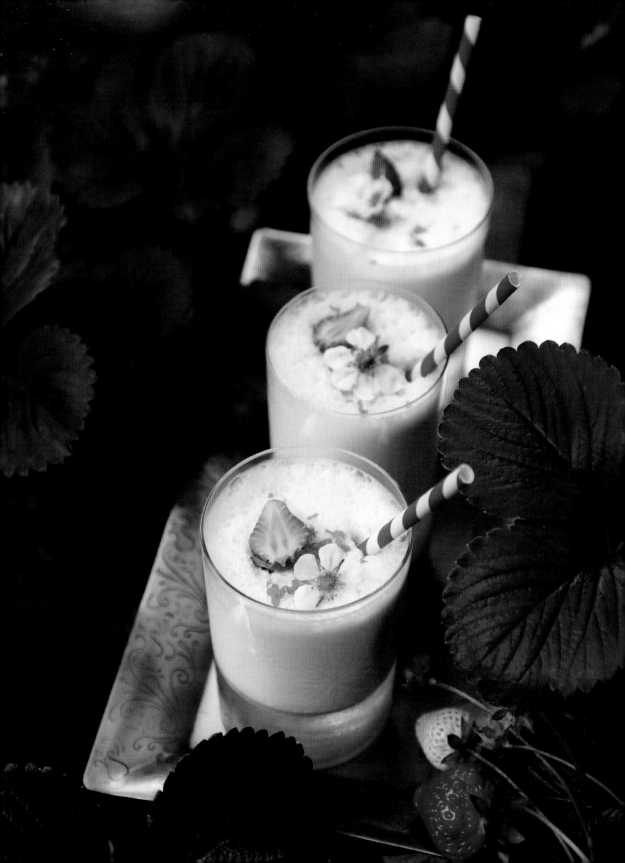

VERDIGRIS COCKTAIL

· MAKES 1 SERVING ·

GLASS SUGGESTION: CHILLED COUPE

If you only have space to grow *one thing* to use in your cocktails, let that be some sort of herb. I beg of you. It will earn its keep tenfold, as both an ingredient and a garnish. Even if all you have is a bright kitchen windowsill, *put some herbs on it*; rosemary, mint, lavender, sage, thyme—they are all cheap dates when it comes to elevating your cocktails. This cocktail's got a few herbs in it.

2 ounces brewed jasmine green tea (prepared according to package instructions, then cooled)

1½ ounces Rosemary-Infused Gin (page 28)

½ ounce freshly squeezed lime juice

½ ounce Basil-Matcha Syrup

½ ounce absinthe

3 drops celery bitters

GARNISH: blossoming rosemary sprig

• In a good ol' cocktail shaker full of ice, combine all ingredients, except garnish. • Shake until chilled, then strain into chilled coupe. • Garnish with rosemary sprig.

BASIL-MATCHA SYRUP

½ cup water

½ cup granulated sugar

½ cup fresh, organic sweet basil leaves

1½ teaspoons matcha powder

Makes ¾ cup. • Combine all ingredients in a small saucepan over medium-high heat. • Stir briskly until all matcha powder and sugar are dissolved. • Remove from heat, let cool thoroughly, strain away or remove basil leaves from mixture, then store syrup in an airtight container in the fridge for up to 2 weeks.

JUNE JULY AUGUST

CHAPTER 2

Summer

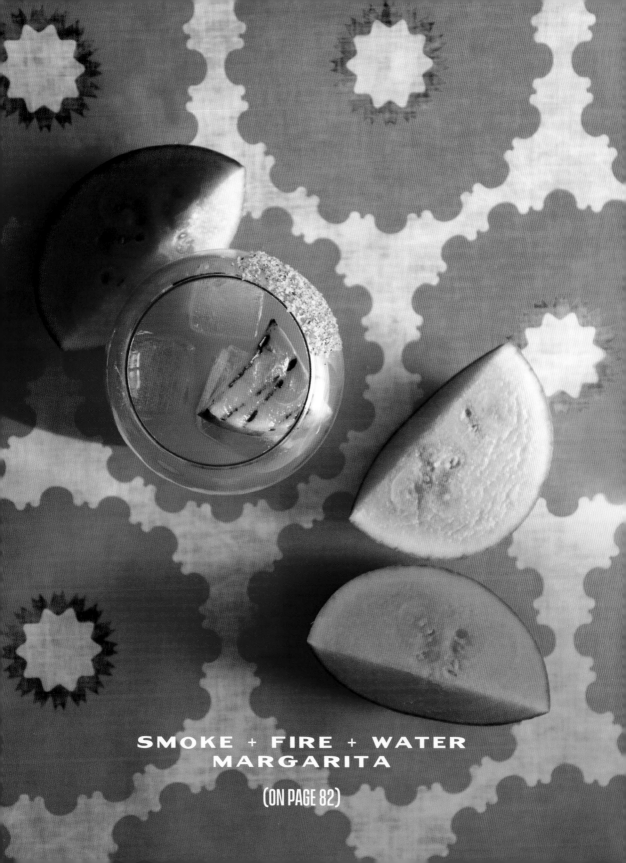

SMOKE + FIRE + WATER
MARGARITA

(ON PAGE 82)

ROSE LEMONADE COLLINS

· MAKES 1 SERVING ·

GLASS SUGGESTION: CHILLED COLLINS GLASS

I have a very obvious affinity for the flavor of rose in my cocktails, if that wasn't already painfully obvious. However, it has been brought to my attention on numerous occasions that some people do not think it tastes as magical as I do. In fact, some might feel it tastes a bit like soap. If you fall into this category, do not despair! I highly suggest jasmine syrup (which can be purchased easily online) as a pretty floral substitute in this little libation. But if you're going to saddle up and come along on this rose cocktail journey with me, making rose syrup from scratch, I highly recommend using dark-colored (red, pink, purple), highly fragrant petals, which will yield a stronger flavor and a lovely pink color to the syrup. And save a few for the chickens. Because: chickens.

An important note about roses: Please only use organically grown roses, or those purchased from a food-safe vendor. It is tempting to buy and use the ones you find at the supermarket, but just don't. When all else fails, use rose water, available at most major food and online retailers. Or buy ready-made rose syrup, which is actually pretty widely available online.

1½ ounces Old Tom gin
1 ounce freshly squeezed lemon juice
½ ounce Rose Syrup
Club soda
GARNISH: lemon slice + maraschino cherry,
　+ organic, fresh rose petals or blossoms

• Fill chilled collins glass with ice and add the gin, lemon juice, and Rose Syrup. • Stir well, top with club soda, then garnish with lemon slice, cherry, and rose petals or blossoms.

ROSE SYRUP

½ cup water
½ cup cane sugar
1 cup fresh, organic, fragrant rose petals,
　or 2 tablespoons rose water

Makes ¾ cup. • In a small saucepan, combine water and sugar, bring mixture to a boil, and heat until sugar is completely dissolved. • Lower heat and add rose petals or rose water, cover and simmer for about 5 minutes. • Remove from heat and allow to cool thoroughly. • If petals were used, strain liquid into an airtight container, or if no petals were used, transfer syrup mixture to an airtight container, and store in the fridge for up to 2 weeks.

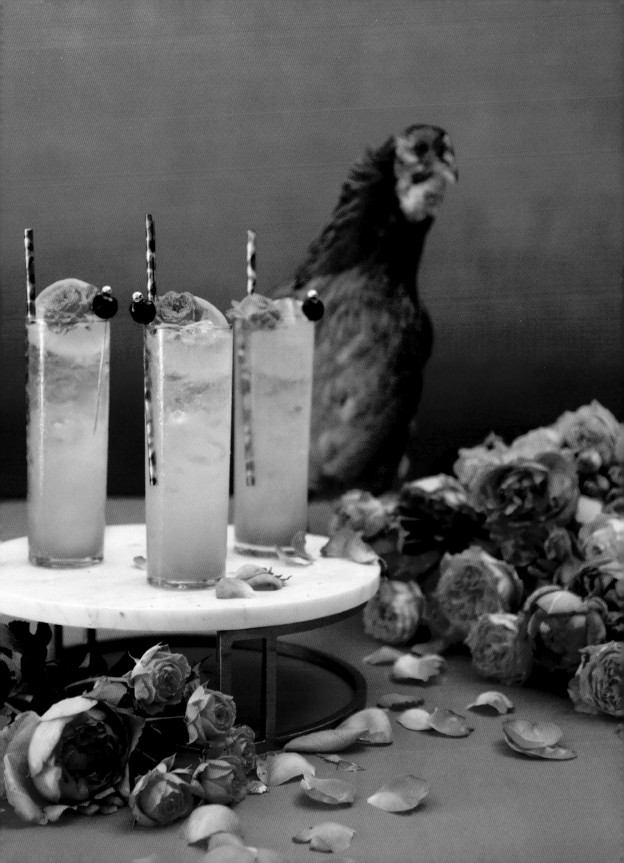

BORAGE + LEMON GIMLET

· MAKES 1 SERVING ·

GLASS SUGGESTION: CHILLED COUPE

Borage is a truly enchanting plant. At first glance, before it blooms, you might take it for some sort of weed, but in reality, it's a fuzzy-leaved stunner with brilliant blue star-shaped blooms that smell and taste faintly of cucumber. It is always humming with pollinators, and when the sun sets behind it and lights up its nimbus of fuzz, it is breathtaking. Not to mention the fact that it is exceptionally easy to grow, and it dutifully reseeds itself every year. And although the chickens will happily gobble an offered handful of blue borage blossoms, mine don't seem to much care for the plant itself; I'm guessing it's too furry. I'm also guessing my chickens are overindulged and ungrateful.

2 ounces gin

1 ounce freshly squeezed lemon juice

1 ounce Borage Simple Syrup

3 fresh lemon balm leaves

GARNISH: borage blossoms + sliced cucumber

• In a shaker with ice, combine all ingredients, except garnishes, and shake until chilled. • Strain into chilled coupe glass and garnish with floating borage blossoms and cucumber slices, or ... whatever you've got. • Garnish it with something!

BORAGE SIMPLE SYRUP

½ cup water

½ cup sugar

½ cup borage leaves and blossoms (no borage? Substitute ½ cup chopped cucumber)

Makes ¾ cup. • In a small saucepan over medium-high heat, bring water and sugar to a boil and heat until sugar is fully dissolved. • Lower heat, add borage, and simmer for 10 minutes. • Remove from heat and allow to fully cool. • Strain mixture into an airtight container and store in the good ol' fridge for up to 2 weeks.

BLACKBERRY SAGE SPRITZER

· *MAKES 1 SERVING* ·

GLASS SUGGESTION: ROCKS GLASS OR LARGE COUPE

Picking blackberries is one of those idyllic summertime activities that, growing up in Los Angeles, I heard tales of people doing. In other places. It wasn't something we did. So it was that I became fixated on growing blackberries in my cocktail garden. Because there is just something wonderful about a muddled blackberry cocktail. Also: it's fun to watch the poultry obliterate a pile of blackberries like a pack of blood-sucking vampires.

5 fresh sage leaves for muddling

1½ ounces dry red wine

½ ounce blackberry liqueur

½ ounce freshly squeezed lemon juice

1 generous tablespoon Honey Blackberry Compote

2 ounces seltzer

GARNISH: blackberries + fresh sage leaves

• In an empty shaker, muddle sage leaves briefly until fragrance is just released. • Add ice. • Now add red wine, blackberry liqueur, lemon juice, and Honey Blackberry Compote. • Shake until chilled. • Strain into glass with ice. • Top with seltzer. • Garnish with blackberries and sage.

HONEY BLACKBERRY COMPOTE

1 mounded cup fresh or frozen, thawed blackberries

½ cup honey

Makes ¾ cup. • In a small bowl, muddle blackberries and honey briefly, cover, and leave to macerate in the fridge for several hours up to overnight.

RED CURRANT CHAMPAGNE COCKTAIL

· MAKES 1 SERVING ·

GLASS SUGGESTION: CHAMPAGNE FLUTE OR COUPE

Two things I love: a classic Champagne cocktail, and fresh, fresh red currants. I happen to find red currants to be the most adorable fruit. They are tiny, perfect little red gems and they come into and out of season so quickly that I just want to grab them and hug them when I find them (I don't *currantly* grow them in my garden. See what I did there?). And, like peas, they are pretty fun to toss and watch the chickens chase. It's something I do whenever I have a few currants leftover from my strange fruit-hugging lovefest.

1 orange peel for rubbing glass

¼ ounce Red Currant Compote

1 demerara sugar cube

3 drops citrus bitters

2 to 4 ounces dry sparkling wine or
 Champagne

GARNISH: 1 smallish cluster red currants
 + 1 orange peel

• Prep your glass: rub the outside edge with orange peel. • Place the Red Currant Compote in the bottom of the glass, then place the sugar cube in the compote. • Drop the bitters directly onto the cube so that they soak into it. • Now, top with bubbly and garnish with currants and orange peel.

RED CURRANT COMPOTE

½ cup red currants

½ cup water

2 tablespoons freshly squeezed lemon juice

Makes ½ cup. • In a small saucepan, bring everything to a boil over medium-high heat. • Lower heat and simmer for 5 minutes, then set aside to fully cool. • Strain mixture through a fine-mesh sieve, smooshing the berries to extract all the currant goodness humanly possible. • Store in an airtight container in the fridge for up to a week.

CUTTING GARDEN MAI TAI

• MAKES 1 SERVING •

GLASS SUGGESTION: ROCKS GLASS

Here's a gorgeous little floral cocktail for sipping while you sit in the summer garden. Or if you don't have a garden to sit in, then for sitting in someone else's. Hopefully, you even know them.

2 ounces aged rum

1 ounce brewed hibiscus tea (prepared according to package instructions, then cooled)

½ ounce pineapple juice

½ ounce freshly squeezed lime juice

½ ounce orgeat (almond) syrup

¼ ounce rose water

4 drops lavender bitters

GARNISH: If you can get your hands on a baby pineapple, then get your hands on a baby pineapple, because it's the cutest garnish ever. If not, just garnish the heck out of it with edible flowers, such as calendula, zinnia, and lavender.

• Prepare your glass by filling with crushed ice.
• In a shaker with ice, combine rum, hibiscus tea, pineapple and lime juices, orgeat syrup, rose water, and bitters, then shake until chilled.
• Strain into prepared glass. • Garnish with tiny pineapple and sprinkle flower petal mixture across the top.

SUMMER BOURBON SMASH

· MAKES 1 SERVING ·

GLASS SUGGESTION: ROCKS GLASS OR JULEP CUP

Just bring me all the nectarines in the summer, okay? Sure, this drink calls for blueberries, as well, but nectarines are the star. They just play so nicely with so many different flavors. You gotta love a fruit that rolls with the punches. Literally: rolls with the punches. It's what happens when the chickens get ahold of a whole one.

1 ounce Nectarine-Blueberry Purée

½ ounce freshly squeezed lemon juice

½ ounce Honey Syrup (page 54)

2 ounces bourbon

2 ounces seltzer, or to top

GARNISH: sliced nectarine + blueberries +
 1 flowering basil sprig

• In the bottom of your glass, combine the Nectarine-Blueberry Purée, lemon juice, and Honey Syrup. • Give the mixture a quick stir, then fill your glass with crushed ice. • Add bourbon, stir again, top with seltzer, and garnish with nectarine slices, blueberries, and basil sprig.

NECTARINE-BLUEBERRY PURÉE

½ cup nectarines, pitted and chopped
 into chunks

12 blueberries, fresh or frozen and thawed

½ ounce freshly squeezed lemon juice

½ ounce honey

Makes ½ cup. • Place nectarines (skins included), blueberries, lemon juice, and honey in a blender or food processor and blend until liquefied and smooth.

SMOKE + FIRE + WATER MARGARITA

· MAKES 1 SERVING ·

GLASS SUGGESTION: ROCKS GLASS, MARGARITA GLASS, OR RANDOM ROUND, AMBIGUOUS PINK GLASS

Mezcal seems to be one of those divisive spirits: people either love it, or they hate it. I was the latter, until I really rolled up my sleeves and set about tasting various brands and varietals. Sometimes, you just have to put in the work. That is, I will drink this until I like it. I'm a professional like that.

But, if mezcal is not for you, just make this little drinky with tequila instead.

1 tablespoon coarse sea salt + 1 tablespoon Tajín seasoning for rimming glass

1 lime wedge for rimming glass

2 ounces Grilled Watermelon Juice

1½ ounces mezcal

½ ounce Habanero-Infused Tequila (page 28)

1 ounce freshly squeezed lime juice

½ ounce orange liqueur, such as Grand Marnier

½ ounce light agave syrup

GARNISH: 1 small slice grilled watermelon

• Prep your glass: Mix salt and Tajín on a small plate. • Run lime wedge along rim of glass, then roll glass in the Tajín mixture, reserving the remaining Tajín mixture. • Fill glass with ice.

• In a cocktail shaker with ice, combine Grilled Watermelon Juice, mezcal, habanero tequila, lime juice, orange liqueur, and agave syrup. • Shake until chilled. • Strain mixture into prepared glass. • Dip a small slice of grilled watermelon into the reserved Tajín mixture and garnish glass with it.

GRILLED WATERMELON JUICE

1 tablespoon light agave syrup

1 tablespoon freshly squeezed lime juice

1 large, round slice of watermelon (about 6 inches across and 1 inch thick), rind re- moved (reserve a few small, thin slices for drink garnish, rind left intact)

Makes approximately 1 cup. • Combine agave and lime juice in a small bowl. • Use this mixture to coat each side of your watermelon slice, then grill the slice, 1 to 2 minutes on each side, until they have a pretty little sear on them. Be sure to grill a few small pieces that you will use for your drink garnish. • Let cool. Then, cut grilled water melon meant for the juice into chunks, place in blender, and blend until liquefied and smooth. • Strain juice through a fine-mesh strainer and store in an airtight container in the fridge for about a week.

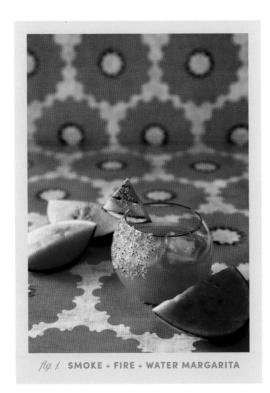

fig. 1. SMOKE + FIRE + WATER MARGARITA

BUTTERFLY FRENCH 75

· MAKES 1 SERVING ·

GLASS SUGGESTION: CHAMPAGNE FLUTE OR COUPE

Ahhhh, the magical, all-natural, color-changing wonder that is blue Butterfly Pea Flower. If you aren't familiar, these lovely pea blossoms create a vibrant blue extract that not only naturally adds a phenomenal indigo hue to beverages, it magically changes to purple or pink with the addition of an acid (read: citrus juice). If you can't grow the plant in your garden, the dried blossoms are easy to come by online, sold as Butterfly Pea Flower Tea. There are also now several brands of gin that use it in their visually stunning bottled spirits.

For this gorgeous cocktail, we'll use it to make a color-changing simple syrup, as well as use one of those fabulous indigo gins. It should also be noted that this drink is just as delicious if you don't use any butterfly pea at all: plain old lavender simple syrup and clear gin will yield the same flavor profile. It just won't be quite as stunning to put your eyeballs on.

Organic lavender blossom to rub glass

1½ ounces indigo gin, such as
 Empress1908 Gin

½ ounce freshly squeezed lemon juice

½ ounce Lavender Butterfly Syrup

3 drops lavender bitters

2 ounces dry sparkling wine or Champagne

GARNISH: 1 organic lavender sprig

• Prepare your glass by rubbing the outside edge of it with the lavender blossom.

• In a cocktail shaker with ice, combine gin, lemon juice, Lavender Butterfly Syrup, and bitters. • Shake until chilled and strain into prepared glass. • Top with sparkling wine and garnish with lavender sprig.

LAVENDER BUTTERFLY SYRUP

½ cup water

½ cup granulated sugar

1 tablespoon fresh or dried organic
 lavender blossoms

1½ teaspoons dried organic blue butterfly
 pea blossoms

Makes ¾ cup. • In a small saucepan, bring water, sugar, and lavender blossoms to a boil. • Allow sugar to fully dissolve, then lower heat, add butterfly blossoms, and simmer for 5 minutes. • Remove mixture from heat, allow to fully cool, then strain solids and store liquids in an airtight container in the fridge for up to 2 weeks. This syrup should be a dark blue color.

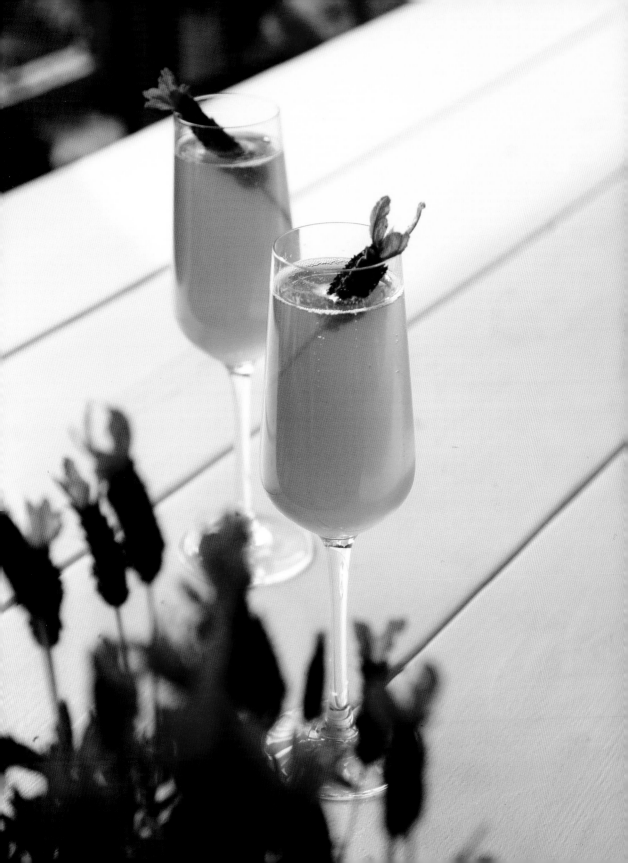

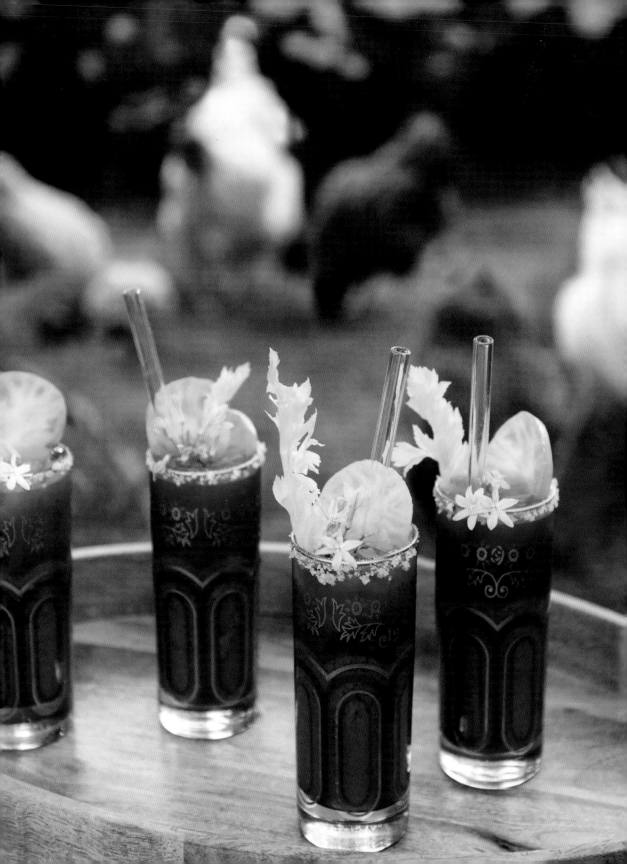

TANGY GREEN TOMATO MARY

· MAKES 4 SERVINGS ·

GLASS SUGGESTION: COLLINS, HIGHBALL, OR PINT GLASS

I'm pretty sure that the original 1920's Bloody Mary didn't have a salted potato chop rim. It also didn't have the veritable meal of a garnish hanging off the top, like crazy brunch enthusiast concoctions do these days. It also wasn't green. But for whatever reason, green tomato varietals go gangbusters in my yard (*lookin' at you, Green Zebra, lookin' at you*), as do tomatillos, so my Bloody Marys tend to be a little less red than other people's. And I'm very ok with that.

1 tablespoon coarse sea salt for rimming glasses

1 tablespoon crushed salted potato chips for rimming glasses

1½ teaspoons celery salt for rimming glasses

Lemon wedge for rimming glasses

3 cups chopped ripe green or yellow tomatoes

1 cup chopped tomatillos

2 cups chopped celery

1 garlic clove

8 ounces chile-infused vodka, such as St. George

4 ounces freshly squeezed lemon juice

1½ teaspoons prepared horseradish (or to taste, depending on how much kick you like)

2 teaspoons Worcestershire sauce

1 tablespoon green Tabasco sauce

GARNISH PER GLASS: 1 slice green or yellow tomato + 1 celery stalk, leaves included + organic garlic chive blossoms

• Combine sea salt, finely crushed potato chips, and celery salt on a small plate. • Prepare glasses by rubbing the lemon wedge around the edge of each, and then dipping the rims into the potato chip mixture to coat. • Fill each glass with ice.

• Next, place tomatoes, tomatillos, chopped celery, and garlic in a blender and blend until liquefied. • Pass mixture through a fine-mesh sieve or cheesecloth and discard solids. • Divide vegetable juice among prepared glasses.

• In a shaker with ice, combine vodka, lemon juice, horseradish, Worcestershire, and Tabasco and shake until chilled. • Strain mixture evenly among all four glasses. • Stir each glass thoroughly, then garnish with skewered small green tomatoes, celery stalk, and chive blossoms.

BALSAMIC STRAWBERRY NEGRONI SBAGLIATO

· *MAKES 1 SERVING* ·

GLASS SUGGESTION: ROCKS GLASS OR WINE GLASS

I love any cocktail recipe that started as an accident. Which is exactly what a Negroni Sbagliato is (*sbagliato* being Italian for "mistaken"). Allegedly it was born when a harried bartender accidentally used sparkling wine instead of gin in a classic Negroni. *Oopsies! I just put champagne in your drink.* How terribly terrible. So, now we're going to take that recipe and mess it up even more, by letting in a Balsamic Strawberry Syrup to play with the other bits. And don't forget to save your strawberry tops for the birds. They'll still judge you while you drink your weird Sbagliato, but at least they'll have strawberry guts smeared on their faces while they do it.

1 ounce Campari or similar grapefruit amaro

1 ounce sweet vermouth

½ ounce Balsamic Strawberry Syrup

2 ounces dry sparkling rosé wine

GARNISH: grapefruit peel + strawberry slices

• In your glass, combine Campari, vermouth, Basil Strawberry Syrup, and ice and stir. • Top with sparkling wine, then garnish with grapefruit peel and strawberry slices.

BALSAMIC STRAWBERRY SYRUP

1½ cups hulled and chopped ripe strawberries

1 teaspoon freshly grated grapefruit zest

¼ cup balsamic vinegar

½ cup water

½ cup granulated sugar

Makes ¾ cup. • Muddle your strawberries in a small bowl to soften and release the juices. • Add the grapefruit zest to the strawberries.

• In a small saucepan, bring vinegar, water, and sugar to a boil over medium heat. • Lower heat, add strawberry mixture, and let simmer for 5 minutes. • Remove from heat and let thoroughly cool, then strain mixture through a fine-mesh sieve and into an airtight container. • Store in the fridge for up to a week.

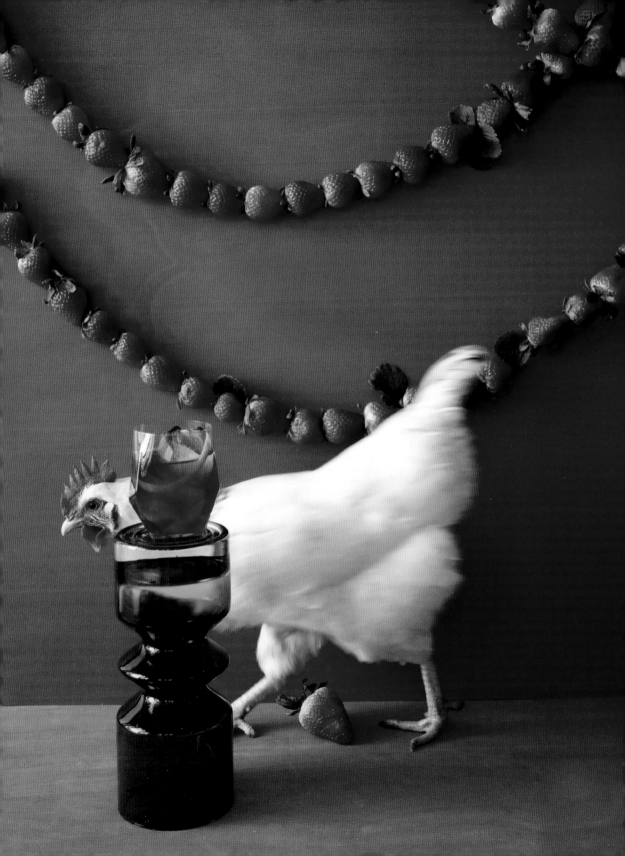

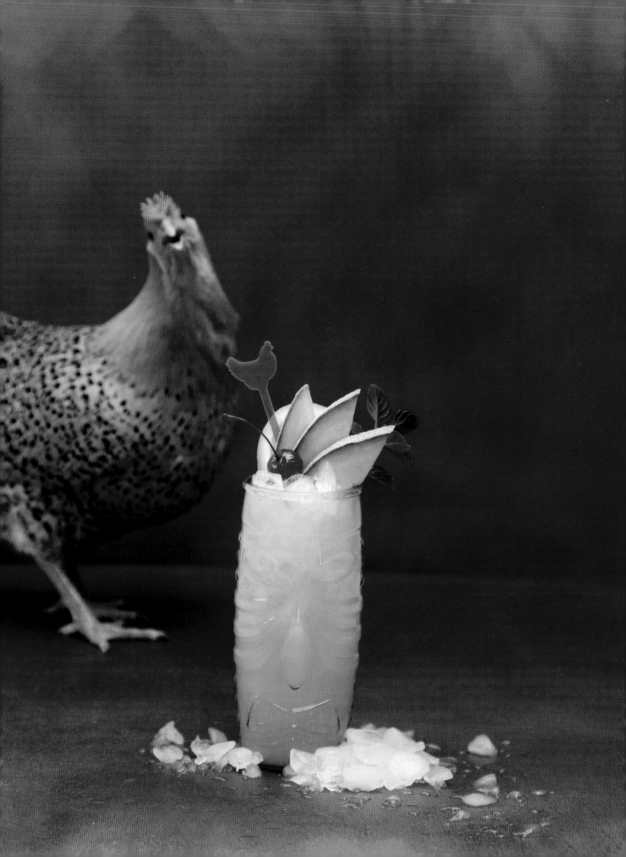

CANTALOUPE MINT RUM PUNCH

· MAKES 1 SERVING ·

GLASS SUGGESTION: FANTASTICAL TIKI MUG OR A PINT OR HIGHBALL GLASS

There are three things that I love about tiki drinks: light rum, dark rum, and no-holds-barred garnish. Don't skimp on the garnish, ever. But especially not on a tiki drink. This one is a fun deviation from the normal tropical rum drink: cantaloupe. *Say what?!* Stay with me here: Cantaloupe is divine with rum. It is easy to carve into whimsical garnish. Ultimately, it is so unassumingly well suited to tiki that it's downright charming. It's the kind of tiki drink you want to take home to Mom. And to cranky chickens.

2 ounces Cantaloupe Juice

2 ounces light rum

½ ounce dark rum

1 ounce freshly squeezed orange juice

½ ounce freshly squeezed lime juice

½ ounce Coconut Mint Syrup

½ ounce orgeat (almond) syrup

GARNISH: cantaloupe + mint sprigs

• Prepare glass by filling with crushed ice.

• In a shaker with ice, combine Cantaloupe Juice, both rums, orange and lime juices, Coconut Mint Syrup, and orgeat. • Shake until chilled, then strain into prepped glass. • Garnish with cantaloupe and mint sprigs.

CANTALOUPE JUICE

½ large cantaloupe, chopped and seeded, rind removed

Makes approximately 1 cup. • Place cantaloupe in a blender or food processor and blend until liquefied. • Strain mixture through a fine-mesh sieve into an airtight container. • Store in fridge for up to a week.

RECIPE CONTINUES ›

COCONUT MINT SYRUP

½ cup canned full-fat coconut milk

½ cup granulated sugar

¼ cup fresh mint leaves

Makes 1 cup. • In a small saucepan over medium heat, bring coconut milk and sugar to a simmer and heat until sugar has fully dissolved. • Lower heat, add mint leaves, and simmer for 3 minutes. • Remove from heat and let thoroughly cool. • Strain into an airtight container and keep in fridge for up to 2 weeks.

CHERRY LAVENDER PISCO SOUR

· *MAKES 1 SERVING* ·

GLASS SUGGESTION: COUPE

Lavender and cherries are just good together. It's one of those flavor combinations that I happened upon accidentally. You know how it goes . . . you're whipping up your second cocktail and make a grab for one ingredient and get the other. Let's just call it destiny, okay?

You might wonder about the pisco, too, if you're not already familiar. It's a type of brandy produced in both Peru and Chile. All it wants is to live with egg whites in a sour little cocktail. And here I am with so many eggs to spare . . . did I mention I have chickens?

1½ ounces pisco

1 ounce freshly squeezed lemon juice

½ ounce Cherry Lavender Syrup

1 medium-size egg white

3 drops lavender bitters

GARNISH: organic lavender blossoms +
 cherries

• In a cocktail shaker with ice, combine pisco, lemon juice, and Cherry Lavender Syrup. • Shake until chilled. • Strain cocktail mixture into another glass, discard the ice from the shaker, add egg white, and reseal. • Shake vigorously for another 30 seconds. • Pour (don't strain) mixture into coupe glass. • Drop bitters across the foam, then garnish with lavender blossoms and skewered cherries.

CHERRY LAVENDER SYRUP

½ cup water

½ cup granulated sugar

½ cup pitted, chopped sweet cherries

1 tablespoon fresh or dried organic lavender
 blossoms

Makes ¾ cup. • Bring water and sugar to a boil in a saucepan over medium-high heat and heat until sugar is fully dissolved. • Lower heat and add cherries. • Simmer for 5 minutes, then add lavender. • Remove from heat and let cool completely. • Using a muddler, gently muddle cherries, then pass the whole mixture through a fine-mesh strainer into an airtight container. • Store in fridge for up to a week.

SPICY TOMATO VODKA SODA

· MAKES 1 SERVING ·

GLASS SUGGESTION: CHILLED COLLINS GLASS

Tomatoes happen to be useful for more than just making Bloody Marys. Here is a simple, savory Mary alternative that's great for brunch (or happy hour, or a predinner cocktail hour, or a nightcap) all through tomato season. It's earthy and it's effervescent. And you're damned right it counts toward your fresh fruits and veggies intake for the day.

Maybe you don't have time to infuse your vodka a week in advance. Don't panic! For a subtler flavor profile, you can muddle two cherry tomatoes and three slices of jalapeño in the bottom of your glass. Add plain vodka and allow the mixture to stew for about 10 minutes, strain the solids, then build your cocktail.

2 ounces Spicy Tomato-Infused
 Vodka (page 29)
½ ounce freshly squeezed lemon juice
3 cherry tomatoes sliced thinly + 5
 jalapeño pepper slices
Plain or lemon-flavored seltzer to
 top, chilled
GARNISH: 1 sprig organic tomato blossom
 if you've got it. Or not.

• In a chilled collins glass, combine Spicy Tomato-Infused Vodka, lemon juice, and a few of the tomato and jalapeño slices. • Add some ice. • Add a few more tomato and jalapeño slices, add more ice, then more slices. • Top off with seltzer and garnish with tomato blossom (if using).

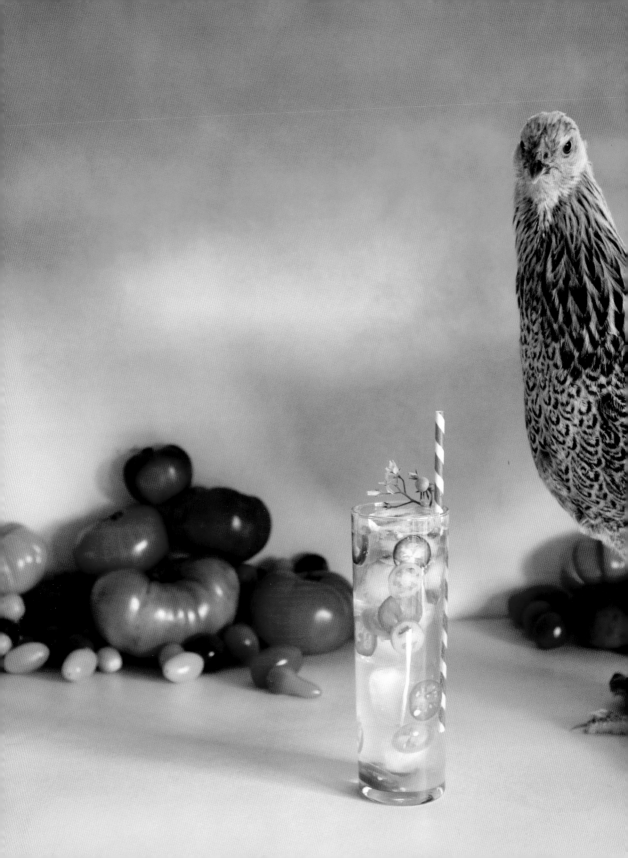

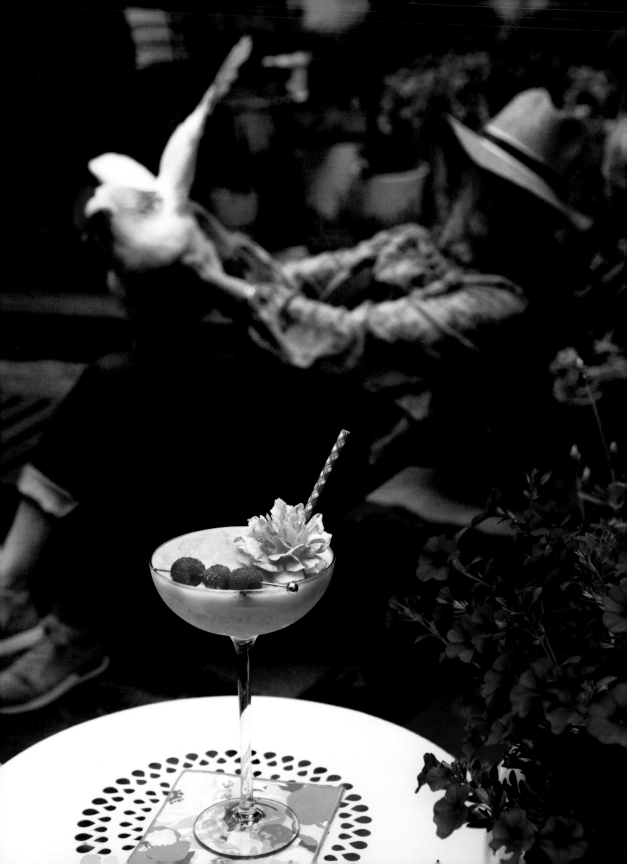

PIÑA ROSADA

· MAKES 2 SERVINGS ·

GLASS SUGGESTION: PINT OR HIGHBALL GLASS, GOBLET, OR TIKI MUG

Sometimes I like to take my favorite standard cocktails and make them pink for absolutely no reason. This is just who I am now. For all intents and purposes, this is a pretty normal blended Colada, aside from the addition of guava juice, rose water, and a touch of raspberry liqueur. Just give into it. Embrace the pink life.

8 ounces guava juice, frozen into cubes

8 ounces pineapple juice, frozen into cubes

3 ounces light rum

3 ounces canned full-fat coconut milk

1 ounce raspberry liqueur, such as Chambord

1 ounce light agave syrup (or Honey Syrup, page 54)

½ ounce rose water

GARNISH: organic rose petals + raspberries

• In a blender, combine frozen guava and pineapple juices, rum, coconut milk, raspberry liqueur, agave, rose water, and ice. • Blend until smooth, then pour into glass of choice. • Garnish with rose petals and raspberries.

BLOSSOM BERRY PUNCH

· MAKES APPROXIMATELY 12 SERVINGS ·

GLASS SUGGESTION: PUNCH GLASS, STEMLESS WINE GLASS, OR ROCKS GLASS

Sometimes you just need a big ol' batch cocktail. Like when you're having a party . . . or doing your taxes. There is something rather enchanting about an elegant punch bowl filled with pretty booze, an ice ring bobbing around as you awkwardly ladle your third helping into a frustratingly tiny punch cup. A note about ice molds: This exact mold (full of edible flowers and berries) is fun to serve to your chickens when it's hot as Hades outside. It will help them cool off while pecking at ice full of pretty things.

3 cups freshly squeezed orange juice

1 cup freshly squeezed lemon juice

1 (946-ml) bottle tart cherry juice

1 (750-ml) bottle gin

1 cup elderflower liqueur, such as
 St-Germain

4 cups tonic water, plus more, chilled, to
 top each glass

2 cups Macerated Mixed Berries

FLOATING GARNISH: ice mold + 2 oranges,
 sliced + 20 decorative, organic flowers

INDIVIDUAL GLASS GARNISH: 12 decorative,
 organic flowers + 12 orange peels +
 36 mixed berries

• In a punchbowl, combine orange and lemon juices, cherry juice, gin, elderflower liqueur, and 4 cups tonic water. • Stir and add ice mold, plus orange slices and flowers.

• To make cocktails, place a spoonful or two of Macerated Mixed Berries into the bottom of a punch cup, ladle in punch mixture, then top with chilled tonic water. • Garnish with a blossom, orange peel, and a few berries.

MACERATED MIXED BERRIES

5 cups mixed berries, such as strawberries,
 blueberries, raspberries, and blackberries
 (or whatever you've got that's in season)

1½ cups granulated sugar

Makes 4 cups. • Mix berries and sugar in a large bowl, slightly mashing berries to release juices. • Cover and store in fridge overnight.

DECORATIVE ICE MOLD

½ cup blueberries

½ cup raspberries

½ cup blackberries

½ cup sliced strawberries

12 edible, organic flowers (I used small decorative-only pink daisies. These are not intended to be consumed.)

• In the bottom of a round Bundt cake mold, arrange a single layer of berries and blossoms. • Add cooled double-boiled distilled water (see page 22), just enough to cover pieces. • Place in freezer and freeze until solid. • Keep adding layers just like this to the mold until it is filled. • When it is time to use it, run hot water over the outside of the mold to release the ice.

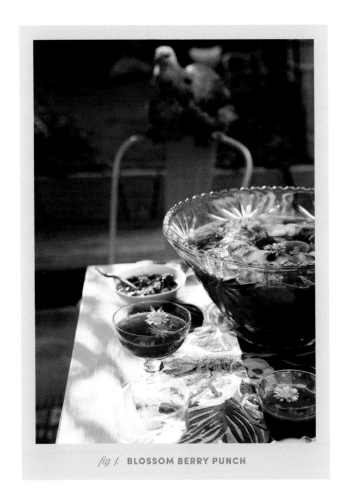

fig. 1. BLOSSOM BERRY PUNCH

SMOKED ARTICHOKE

· MAKES 1 SERVING ·

GLASS SUGGESTION: ROCKS GLASS

Artichokes have always been a fixture in my garden for as long back as I can remember; it was one of the few things my dad obsessively grew in the garden when I was a kid because he absolutely lived for fresh, grilled artichokes in the summer. He still gets really happy about eating artichokes and he's probably going to be embarrassed that I felt the need to mention this in the book. Which is all a long-winded way of saying that I, too, must always have artichokes in the garden.

This cocktail is inspired by the grilled artichokes that my dad is going to pretend he isn't even *that* into.

5 fresh sage leaves for muddling

2 ounces rye whiskey (I used Standard Wormwood Rye)

1½ ounces Cynar (artichoke liqueur)

1½ ounces freshly squeezed lemon juice

1 ounce mezcal

1 ounce aquafaba (page 13)

GARNISH: 1 small artichoke leaf or 3 sage leaves

• In the bottom of a shaker, muddle sage leaves. Add ice, then rye, Cynar, lemon juice, and mezcal. • Shake until chilled, strain away ice, then add aquafaba to the cocktail mixture and continue to shake. • Pour into a rocks glass over ice and garnish with the artichoke leaf or sage leaves.

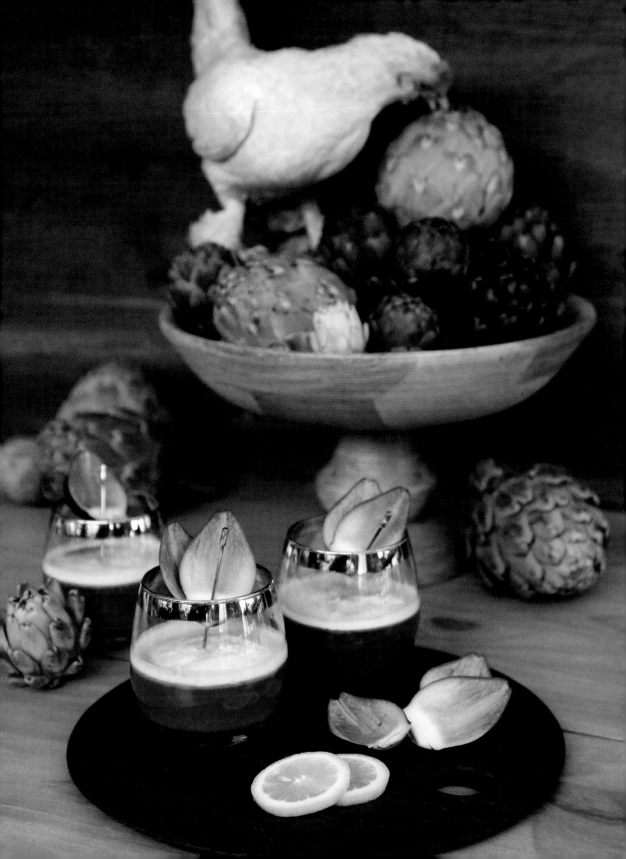

CHAPTER 3

Autumn

GOLDEN GREENS SPARKLER

(ON PAGE 116)

POMEGRANATE SHANDY FLOAT

· MAKES 1 SERVING ·

GLASS SUGGESTION: PINT GLASS OR BEER MUG, CHILLED

Your normal everyday shandy is essentially lemonade mixed with beer. It's a summer drink, really, and you'll find all sorts of variations using all sorts of beers and citrus juices. But I felt like we needed a fall shandy. Something to ease us gently from summer to fall. Ice cream helps with that.

2 scoops vanilla ice cream

1 ounce Orange Grenadine or store-bought grenadine + ½ ounce to drizzle over top

2 ounces freshly squeezed orange juice, chilled

6 ounces chilled wheat, amber, or IPA beer

GARNISH: orange zest + pomegranate arils (seeds)

• Place both ice cream scoops in your chilled glass of choice, then drizzle 1 ounce of Orange Grenadine over the top. • Add orange juice, then top with beer. • Drizzle remaining grenadine over the top, then garnish by zesting orange peel into the beer foam and sprinkling a few pom arils into it.

ORANGE GRENADINE

½ cup pomegranate juice

½ cup granulated sugar

Peel of 1 orange

1 tablespoon freshly squeezed lemon juice

Makes ¾ cup. • In a small saucepan, combine pom juice, sugar, and orange peel and bring to a boil over medium-high heat. • Heat just until sugar has fully dissolved. • Lower heat and simmer for 3 to 5 minutes. • Add lemon juice, stir, and remove from heat. • Set aside and let cool, then strain and transfer to an airtight container and store in fridge for up to 2 weeks.

AUTUMN SOLSTICE SANGRIA

· MAKES APPROXIMATELY 12 SERVINGS ·

GLASS SUGGESTION: WINE GLASSES

I really love a good fall fruit sangria. But we're going to go a little rogue. We're going to use rosé instead of red wine. I know, I know: gasp! It's not rosé season anymore. But listen . . . ain't nobody gonna tell me when I can and cannot have my rosé, okay? Okay. But, honestly, when you fill it with all the moody autumn fruits (those shown here are just suggestions; use whatever is available), it actually makes a gorgeous, transitional summer-to-fall beverage. For which you can then invite your (human) friends over to drink batch cocktails and stare at chickens. And people will totally show up for that. No, I swear. They will.

2 dark red apples, sliced thinly, seeds removed

2 red-skinned pears, sliced thinly, seeds removed

8 fresh figs, halved

2 red plums, pitted and sliced thinly

20 Concord grapes, sliced thinly

3 tablespoons granulated sugar

½ cup brandy

½ cup freshly squeezed orange juice

2 (750-ml) bottles preferably deep pink rosé wine, such as rosé of pinot

• In a large pitcher, combine fruit, sugar, and brandy. • Stir well. • Set in fridge to chill overnight. • When ready to make sangria, combine fruit mixture (including its brandy) with orange juice and wine in a large beverage dispenser. • Serve sangria over ice, topped with pieces of the boozy fruit.

APPLE BUTTER BUTTERED RUM

· MAKES 1 SERVING ·

GLASS SUGGESTION: HEATPROOF MUG, HOT TODDY MUG, OR IRISH COFFEE MUG

Since it's finally fall, it's probably time to start slowly phasing in the warm drinks, like this apple cider-y spin on traditional hot buttered rum. It's perfect for cozying up by the fireplace, or for pensively sipping while wrapped in a cushy blanket, or if you're me in Southern California, where it's probably still unseasonably hot, you'll sit outside in the chicken yard and drink it out of principle even though you're sweating buckets and not cozy in the slightest.

2 tablespoons Apple Butter Butter

2 ounces dark spiced rum

½ ounce apple brandy

½ ounce Honey Syrup (page 54)

2 ounces boiling water

GARNISH: 1 thin apple slice

• Prepare your glass by spooning Apple Butter Butter into the bottom. • Add rum, apple brandy, and Honey Syrup. • Top the glass with boiling water, and garnish with apple slice.

APPLE BUTTER BUTTER

½ cup (1 stick) unsalted butter, at room temperature

2 tablespoons apple butter

1 tablespoon honey

Makes ¾ cup. • Combine all ingredients in the bowl of an electric mixer and beat until blended. • Scoop mixture onto a sheet of waxed paper and form mixture into a log shape. • Roll the waxed paper around it and twist the ends of the waxed paper closed. • Store in fridge for up to 3 weeks, or in freezer indefinitely.

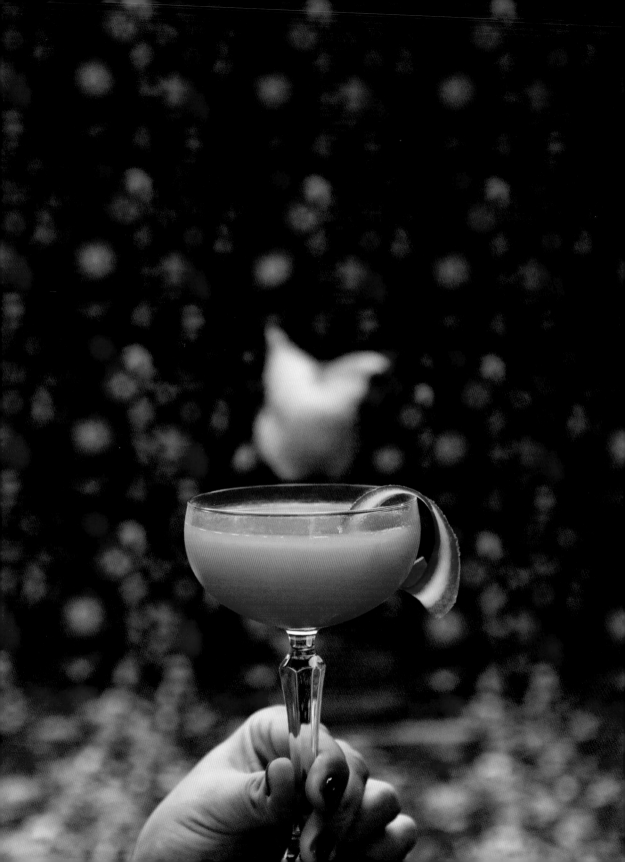

HONEY-GLAZED CARROT SIDECAR

· *MAKES 1 SERVING* ·

GLASS SUGGESTION: CHILLED COUPE

Or, as I like to refer to it, the Sidecarrot. Carrots in cocktails can be a little hit or miss. They have a certain earthy sweetness to them that can either play very well with other ingredients, or make the whole damned thing taste like dirt. I'm all for umami cocktails, but dirt-flavored is going a tad bit off course for my palate. It's all about balance. So, we're going to sweeten up those carrots and put them in a little cognac cocktail.

2 ounces cognac

½ ounce dry curaçao (not the sweet sugary kind, the dry kind)

½ ounce Honey-Glazed Carrot Syrup

½ ounce carrot juice

½ ounce freshly squeezed lemon juice

GARNISH: carrot ribbon

• In a shaker with ice, combine all ingredients, except garnish. • Shake until chilled, then strain into a chilled coupe glass. • Garnish with a thin ribbon of colorful carrot.

HONEY-GLAZED CARROT SYRUP

½ cup store-bought or freshly juiced carrot juice

¼ cup dark brown sugar

¼ cup honey

1 tablespoon freshly squeezed lemon juice

Makes ½ cup. • Combine all ingredients, except lemon juice, in a small saucepan over medium-high heat and bring to a boil. • Heat until sugar and honey are fully dissolved. • Lower heat and simmer for 3 to 5 minutes to thicken. • Remove from heat, add lemon juice, stir, and allow mixture to fully cool. • Transfer to an airtight container and store in the fridge for up to 2 weeks.

GOLDEN GREENS SPARKLER

· MAKES 1 SERVING ·

GLASS SUGGESTION: PINT, COLLINS, OR HIGHBALL GLASS

Yes. This is a chard cocktail. And not the chardonnay kind of chard: the healthy kind. And you are going to drink it and *you are going to like it*. Or at least pretend to for my benefit, okay? Plus, if you have chickens, you probably know that they love Swiss chard. You've got to grow it anyway to throw at them from time to time, so you may as well also throw some in with your booze. I'm just trying to keep you healthy. This recipe calls for Swiss chard juice, but really, any kind of bottled green juice from the store will work. Otherwise, if you've got a juicer or a blender, you can make your own.

Thinly sliced apples + thickly sliced limes to
 prepare glass

1 ounce green Chartreuse liqueur

1½ ounces freshly squeezed lime juice

1½ ounces Lillet Blanc or Cocchi Americano

1 ounce Chard + Green Apple Syrup

1 ounce ginger beer

2 ounces club soda

GARNISH: curly kale, chard, or other green
 leafy thing

• First, prepare your glass. • Fill with ice, sliding in slices of lime and apple along the side of the glass as you go.

• In a shaker with ice, combine Chartreuse, lime juice, Lillet, and Chard + Green Apple Syrup. • Shake until chilled, then strain into prepared glass. • Top with ginger beer, then club soda, and garnish with some pretty greens.

SWISS CHARD JUICE

½ cup water

4 large leaves Swiss chard, stems removed

Juice of 1 lime

Makes ½ cup. • Combine all ingredients in a blender and process until smooth. • Strain mixture through a fine-mesh sieve. • Set aside.

CHARD + GREEN APPLE SYRUP

½ cup granulated sugar

½ cup Swiss Chard Juice, or other green juice

1 large Granny Smith apple, cored and chopped

1 tablespoon freshly squeezed lime juice

Makes ½ cup. • In a medium saucepan over medium-high heat, combine sugar, Swiss Chard Juice, and apple and bring to a boil. • Lower heat to a simmer and cook for 5 minutes. • Remove from heat, add lime juice, and allow to cool. • Strain into an airtight container, smooshing the juices from the apples through a fine-mesh sieve, and store in fridge for no longer than a day.

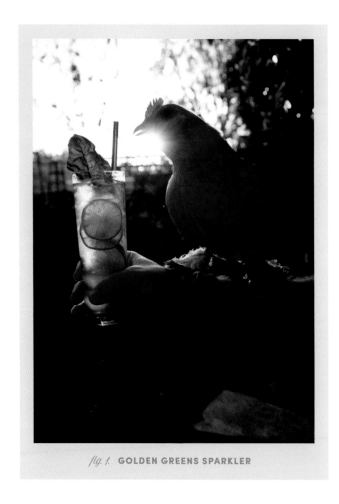

fig. 1. **GOLDEN GREENS SPARKLER**

MULLED PEAR COBBLER

· *MAKES 1 SERVING* ·

GLASS SUGGESTION: WINE GOBLET OR COLLINS GLASS, CHILLED

I do not own a pear tree. And it makes me very sad. But fortunately for me, I have several friends who have them, whom I consistently harass enough that I wind up with bags of fresh fruit during the season. The squeaky wheel gets the most pears: fact. Also of note: this cocktail makes me think of pie. And I rather like to think about pie.

2 ounces brandy

½ ounce amaretto liqueur

½ ounce Mulled Pear Syrup

1 ounce freshly squeezed lemon juice

GARNISH: thin slice of pear + dusting of ground cinnamon

• Prepare glass by filling with crushed or pellet ice. • In a cocktail shaker with ice, combine brandy, amaretto, Mulled Pear Syrup, and lemon juice and shake until chilled. • Strain mixture into prepared glass and garnish with slice of pear and a light dusting of ground cinnamon.

MULLED PEAR SYRUP

1 pear, cored and chopped (about 1 cup chopped)

½ cup granulated sugar

½ cup water

1 cardamom pod

2 whole cloves

1 allspice berry

1 stick cinnamon

Pinch of freshly grated nutmeg

Makes ¾ cup. • Combine all ingredients in a small saucepan, bring to a boil over medium-high heat, and heat until sugar has fully dissolved. • Lower heat and simmer for 5 minutes, then remove from heat and allow to cool. • Strain away solids and place liquids in an airtight container and store in fridge for up to 2 weeks.

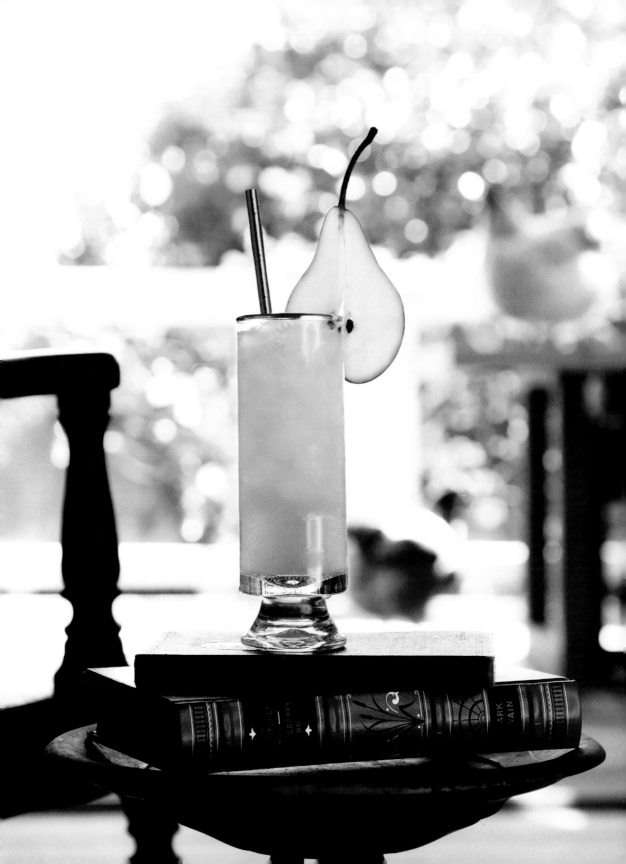

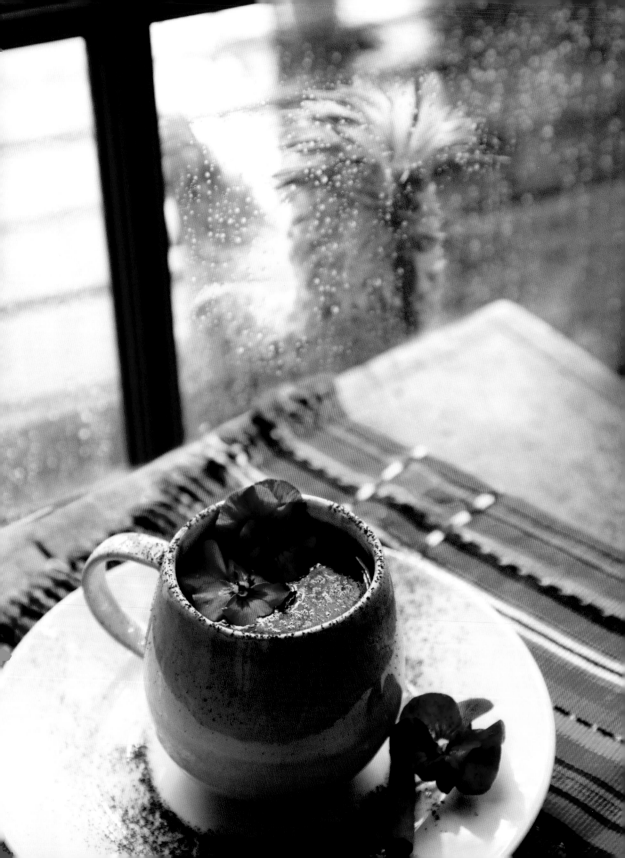

SPICED SALTED DARK COCOA

· *MAKES 1 SERVING* ·

GLASS SUGGESTION: MUG

It's fall. It's probably starting to rain outside, or maybe even snow. Except in SoCal; it's probably all the way down to a frigid 65 degrees here. Time to break out the hot chocolate, but let's warm it up even more with some habanero and booze, okay? It's the perfect thing to drink while it's raining outside and you sit in the comfort of your warm, dry living room, making awkward eye contact through the window with a mad wet hen.

Remember that Habanero-Infused Tequila we made for the Smoke + Fire + Water Margarita way back in the summer, on page 28? Hope you kept it.

1 cup plus 2 tablespoons coconut milk
 beverage, divided
2 tablespoons unsweetened dark cocoa
 powder
Pinch of sea salt
½ ounce Cinnamon Syrup
1 ounce Habanero-Infused Tequila (page 28)
½ ounce Cointreau or other orange liqueur
GARNISH: unsweetened cocoa powder +
 1 stick cinnamon + edible, organic blooms
 (such as pansies)

• In a small saucepan, combine 2 tablespoons milk with cocoa powder, sea salt, and Cinnamon Syrup. • Stir over medium-high heat until everything is dissolved, then add remaining cup of milk. • Stir to integrate fully and remove from heat.

• In the bottom of a mug, combine tequila and Cointreau. • Pour in hot chocolate mixture. • Dust mug with cocoa powder, then garnish with cinnamon stick and edible blooms.

CINNAMON SYRUP

½ cup water
3 sticks cinnamon
½ cup granulated sugar

Makes ½ cup. • Bring water and cinnamon sticks to a boil in a small saucepan over medium-high heat. • Lower heat and simmer for 5 minutes, then add sugar and simmer until sugar is completely dissolved. • Remove from heat and allow to cool, then strain into an airtight container, discarding cinnamon sticks, and store in fridge for up to 2 weeks.

PERSIMMON SCOFFLAW

· *MAKES 1 SERVING* ·

GLASS SUGGESTION: COUPE

I have such a soft spot for the Fuyu persimmon. Those tiny orange tree tomatoes make my fall-loving heart happy. We used to have a gorgeous Fuyu tree but, long story long, it had to come down for multiple reasons, not the least of which was that we needed space for an outdoor bar near the chicken yard. Priorities. So, the adorable persimmon always seems to show up in my autumn cocktails. Like in this twist on the Prohibition-era Scofflaw. Yes, I like making Scofflaws just so I can say the word "Scofflaw." If you don't have a fresh persimmon to use in your Scofflaw, it's easy to come by dried fruit online and in specialty stores. Scofflaw.

2 ounces bourbon

1 ounce dry vermouth

½ ounce freshly squeezed lemon juice

½ ounce Cinnamon Persimmon Syrup

3 dashes of orange bitters

GARNISH: 1 wheel fresh persimmon studded with 4 cloves + edible bloom

• In a shaker with ice, combine bourbon, vermouth, lemon juice, Cinnamon Persimmon Syrup, and bitters. • Shake until chilled. • Strain into a coupe and garnish.

CINNAMON PERSIMMON SYRUP

½ cup granulated sugar

½ cup water

1 cinnamon stick

½ cup chopped fresh persimmon, or 2 tablespoons diced dried

Makes ½ cup. • Combine sugar, water, and cinnamon stick in a small saucepan over medium-high heat and bring to a boil, stirring occasionally until sugar is dissolved. • Lower heat to a simmer and add persimmon. • Simmer for 3 minutes, then remove from heat and allow to cool. • Strain into an airtight container and store in fridge for up to 2 weeks.

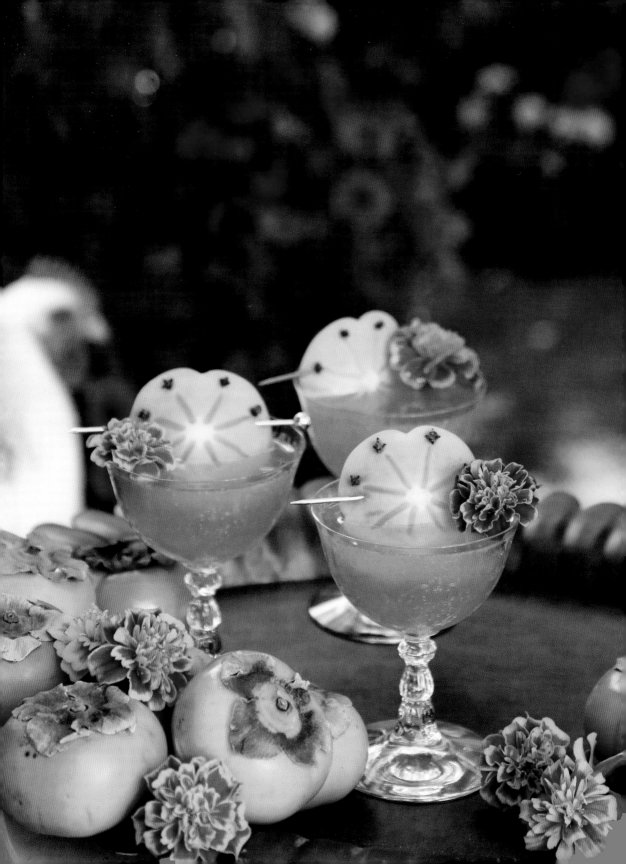

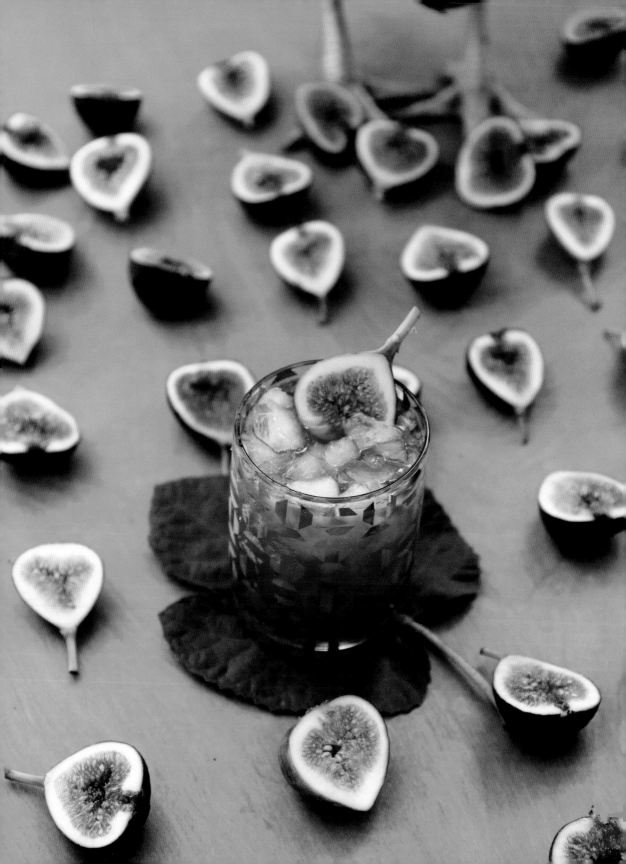

FIG MAI TAI

· MAKES 1 SERVING ·

GLASS SUGGESTION: CHILLED ROCKS GLASS

What's that? Another mai tai recipe?! YUP. There's one for every season, my friends. This one's full of figs. And rum. It also features a honey-based fig simple syrup, and for some reason, every time that I've made it, bees fly into my house. Every. Damned. Time. Not-so-Pro Tip: close your doors while cooking honey simple syrup.

1 ripe fig, sliced in half, for muddling

2 ounces dark spiced rum

1 ounce freshly squeezed lime juice

½ ounce Spiced Fig and Honey Syrup

½ ounce dry orange curaçao

3 drops aromatic bitters

GARNISH: ½ ripe fig

• Fill rocks glass with crushed ice. In the bottom of a cocktail shaker, muddle the halved fig. • Add ice, and then add rum, lime juice, Spiced Fig and Honey Syrup, curaçao, and bitters. • Shake thoroughly until chilled. • Strain into glass, garnish with halved fig. • And if you want to be real clever, make coasters out of fig leaves.

SPICED FIG AND HONEY SYRUP

1 stick cinnamon

2 whole cloves

½ cup water

½ cup honey

4 ripe figs, quartered

Makes ¾ cup. • Place cinnamon stick, cloves, and water in a small saucepan and bring to a boil over high heat. • Boil for about 2 minutes, then lower heat to medium-low and add honey and figs. • Simmer for about 3 minutes. Shoo away bees. • Remove from heat and smash figs against the sides of the pot. • Allow mixture to cool, then strain it into an airtight container and store in fridge for up to 2 weeks.

ORANGE-POMEGRANATE CHAI TODDY

· *MAKES 1 SERVING* ·

GLASS SUGGESTION: HEATPROOF MUG, HOT TODDY, OR IRISH COFFEE MUG

A fragrant, hot beverage to hold in your cold little hands while you stand in the chicken garden pep-talking your poultry through their annual molt. Chickens drop all their feathers just as it's getting cold (*why, why?*) and awkwardly grow a whole new set. And it's usually pretty pathetic, and rather hard to watch (until the new feathers grow in fully and they look like *glorious, glimmering peacocks*). So, you're going to need a bit of warm booze in your belly to help you through it. And maybe feed them some extra treats, because being a half-naked chicken is rough, man.

1 tea bag chai-spiced black tea

4 ounces hot water

½ ounce Orange Grenadine (page 108)

½ ounce freshly squeezed orange juice

2 ounces Orange Peel Whiskey (page 27)

GARNISH: orange wheel slice + 1 teaspoon pomegranate arils + 1 stick cinnamon

• Place tea bag in mug and pour hot water over it. • Stir in Orange Grenadine and allow to steep for 3 to 4 minutes. • Discard the tea bag, then add orange juice and Orange Peel Whiskey and stir thoroughly. • Place cinnamon stick in cocktail, float an orange wheel on top of the cocktail, and sprinkle arils on top of this as if to create a little life raft.

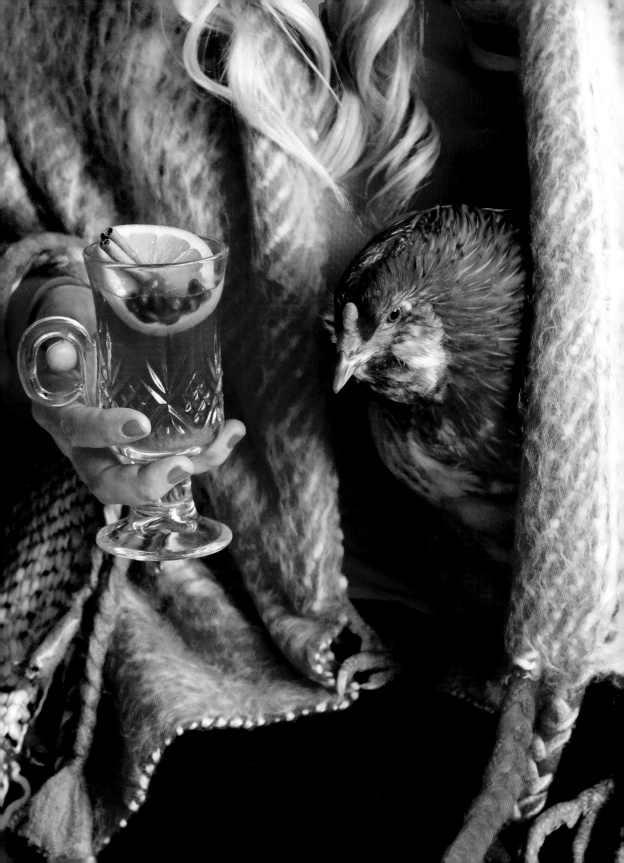

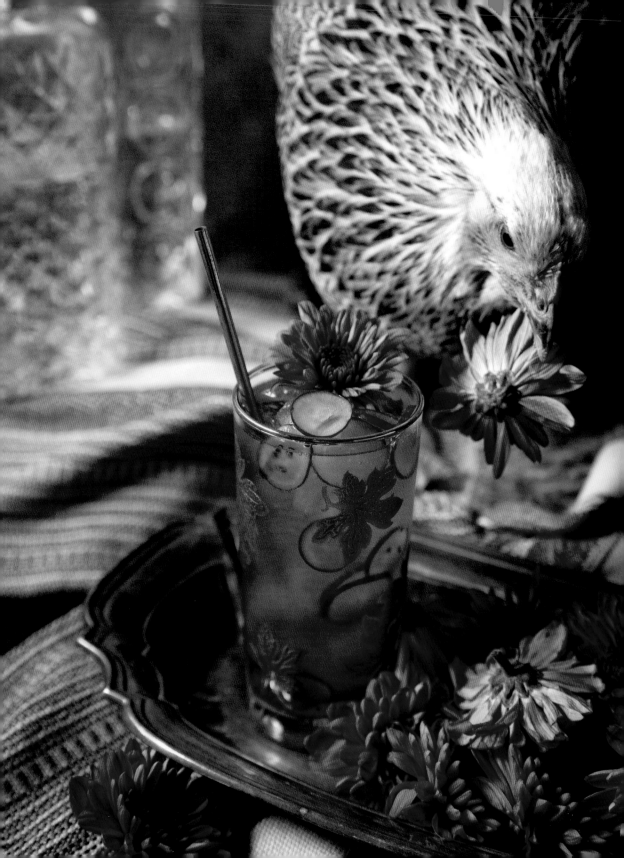

SPICED GRAPE MOJITO

· MAKES 1 SERVING ·

GLASS SUGGESTION: CHILLED COLLINS, HIGHBALL, OR PINT GLASS

Grapes. Who knew they were good with rum? And smashing them is properly fun, so let's put them in this Mojito spin-off.

Remember the Cinnamon Syrup we made for the Spiced Salted Dark Cocoa (page 121)? Maybe you even have some left over? Well, we're going to use it again.

1 ounce freshly squeezed lemon juice

4 dark-skinned, seedless grapes, cut in half, for muddling

½ ounce Cinnamon Syrup (page 121)

3 drops aromatic bitters

4 dark grapes, sliced paper thin

½ ounce elderflower liqueur, such as St-Germain

2 ounces light rum

1 ounce club soda

GARNISH: dark grapes, sliced paper thin

• Combine lemon juice, 4 halved grapes, Cinnamon Syrup, and bitters in bottom of glass and muddle. • Fill glass with small ice cubes, layering them in along with the thin grape slices. • Once glass is filled with ice, add elderflower liqueur and rum, and top with club soda. • Garnish with more grape slices.

MAPLE SAGE PUMPKIN FLIP

· MAKES 1 SERVING ·

GLASS SUGGESTION: CHILLED COUPE

Ahhhh, pumpkin. It's the fall, so we should have pumpkin. It's not really my most favorite flavor, but I figured it would be a pretty poor effort on my part if I didn't include at least *one* pumpkin recipe in this book. But I refuse to pumpkin-spice it. And I ain't sorry.

Coincidentally, my chickens also don't seem to enjoy eating pumpkin, even though theoretically they should. They do, in fact, fancy climbing all over them for photo shoots, but split a pumpkin open for them to eat and they run in mortal terror. It's truly weird.

For ease, we're going to use canned pumpkin pie filling, but we'll still pull sage and lemons from the garden. If I went to the trouble of using fresh pumpkin, I would inevitably have some left over that I would try to feed to the poultry, and we all know how that would work out.

5 fresh sage leaves for muddling

2 ounces bourbon

1 tablespoon pure pumpkin purée

½ ounce amaretto

½ ounce freshly squeezed lemon juice

½ ounce pure maple syrup

Pinch of freshly grated nutmeg

4 drops cardamom bitters

1 medium egg white

GARNISH: fresh sage leaves + dusting of freshly grated nutmeg

• In the bottom of a shaker, muddle 5 sage leaves just until the fragrance releases. • Combine bourbon, pumpkin purée, amaretto, lemon juice, maple syrup, nutmeg, bitters, and egg white in a shaker. • Shake vigorously until egg whites are foamed. • Add ice to shaker and shake until chilled. • Strain contents into a coupe glass. • Garnish with fresh sage leaves and a dusting of nutmeg across the foam.

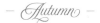
SUGARED HOPS SCOTCH

· *MAKES 1 SERVING* ·

GLASS SUGGESTION: ROCKS GLASS

If you're not an IPA lover, you might want to move along. This one's probably not for you. Personally, I love hops—the flavor, the smell, the flowers—and I love the way the vines will ramble over everything with zero respect for personal space. And I really, really love a good hoppy IPA. If you don't have access to fresh hops, dried are really easy to come by online and at specialty food stores.

1½ ounces scotch

1 ounce chilled Hops Black Tea

1 ounce freshly squeezed orange juice

1 ounce Brown Sugar IPA Syrup

¼ ounce freshly squeezed lemon juice

3 drops orange bitters

GARNISH: 1 orange slice + 1 tablespoon fresh or dried hop blossoms

• In a shaker with ice, combine all ingredients, except garnishes, and shake until chilled.
• Strain over ice in a chilled rocks glass. • Garnish with orange slice and hop blossoms.

BROWN SUGAR IPA SYRUP

½ cup really hop-forward IPA

½ cup brown sugar

¼ cup freshly squeezed orange juice

Makes ¾ cup. • Bring all ingredients to a boil in a small saucepan over medium-high heat and heat until the sugar has fully dissolved. • Lower heat and simmer for about 5 minutes. • Remove from heat, allow to cool, then transfer to an airtight container and store in the fridge for up to 2 weeks.

RECIPE CONTINUES ›

HOPS BLACK TEA

1 tea bag black tea

6 fresh hop blossoms, or 1 tablespoon dried
 hop blossoms

1 cup boiling water

Makes 1 cup. • Combine tea bag, hops, and water in small airtight container, such as a mason jar and allow to steep for 5 minutes. • Strain away solids and allow tea to cool in fridge until ready to use.

fig. 2. SUGARED HOPS SCOTCH

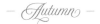

BEET SANGAREE

· MAKES APPROXIMATELY 8 SERVINGS ·

SUGGESTED GLASSWARE: SMALL WINE GLASS,
COUPE, OR PUNCH CUP

Nope. Not sangria. *San-ga-ree*. It's sort of an old-timey sangria-like punch (*historical cocktails for the win!*), which probably originated in the Antilles islands somewhere in the late 1700s. The exact recipe is a little fluid (literally *and* figuratively), but was basically a use-what-ya-got mixture of red wine or port, arrack (a rumlike spirit), citrus, sugar, and spices, such as anise and/or nutmeg. Later incarnations might swap out the arrack for other booze, such as brandy or ale, and some recipes leave out the citrus altogether. So, in the spirit (*booze puns!*) of rather flexibly recorded old recipes, we're going to do our own spin. Also, we're going to batch it because that's just fun.

1 (750-ml) bottle dry red wine (the
 Spanisher, the betterer)

1 (750-ml) bottle ruby port

1½ cups dark rum

1 cup freshly squeezed orange juice

½ cup freshly squeezed lemon juice

½ cup Beet Syrup

15 drops Angostura bitters

5 star anise seeds

1 medium-size orange, sliced

3 beets, various colors, trimmed but not
 peeled, then sliced

GARNISH: 24 multicolored beet slices,
 divided + 12 anise seeds, divided +
 12 spiraled orange peels, divided

• In a large pitcher, combine all ingredients, except garnishes, and stir. • Store in fridge for several hours or up to 1 day to fully infuse. Just before serving, stir well. • To serve, fill each glass with infused beet and orange slices from the pitcher, then top up with cocktail. • Garnish with fresh beet slices, a star anise seed, and an orange peel.

RECIPE CONTINUES ›

BEET SYRUP

¾ cup store-bought or freshly juiced
 beet juice

½ cup granulated sugar

Makes 1 cup. • In a small saucepan over medium-high heat, combine beet juice and sugar and bring to a boil. • Heat until sugar has fully dissolved. • Remove from heat and let fully cool, then strain into an airtight container and store in the fridge for up to 2 weeks.

fig. 1. **BEET SANGAREE**

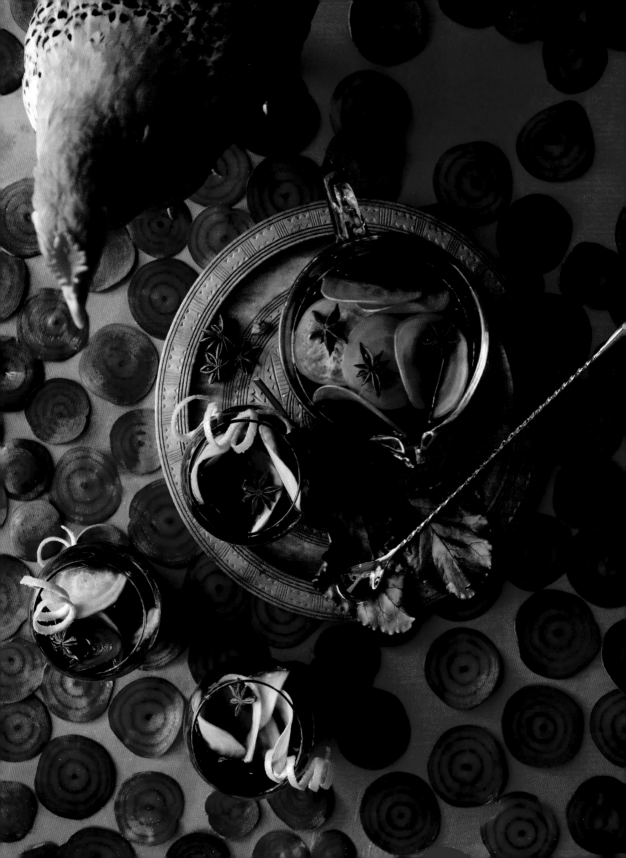

CARDAMOM + PLUM OLD-FASHIONED

· *MAKES 1 SERVING* ·

GLASS SUGGESTION: ROCKS GLASS

There was an enormous plum tree that lived directly outside the window of my childhood bedroom. It would blossom like crazy every year and would fill with fruit and then, in the matter of a couple of days, drop said fruit everywhere. I spent a lot of time under that tree, eating plums like a feral pig. Ah, memories. But this is probably partially responsible for my love for a good plum cocktail these days.

1 teaspoon Cardamom Plum Syrup

3 dashes of cardamom or aromatic bitters

1 slice orange peel

2 ounces bourbon

GARNISH: plum slices + Luxardo cherry

• In the bottom of a rocks glass, combine Cardamom Plum Syrup and bitters. • Add a large ice cube, then stir thoroughly. • Twist orange peel over the glass to express oils, and drop it in glass. • Add bourbon, stir thoroughly, then garnish with plum slices and cherry.

CARDAMOM PLUM SYRUP

1 plum, pitted and chopped

4 cardamom pods

½ cup dark brown sugar

½ cup water

Makes ¾ cup. • Combine all ingredients in a small saucepan over medium-high heat. • Bring to a boil, heat until sugar dissolves, then lower heat to low and simmer for 3 to 5 minutes. • Remove from heat and allow to cool thoroughly. • Strain into an airtight container and store in fridge for up to 2 weeks.

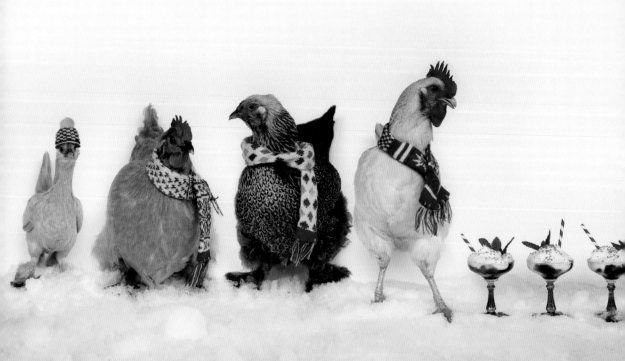

DEC. JAN. FEB.

CHAPTER 4

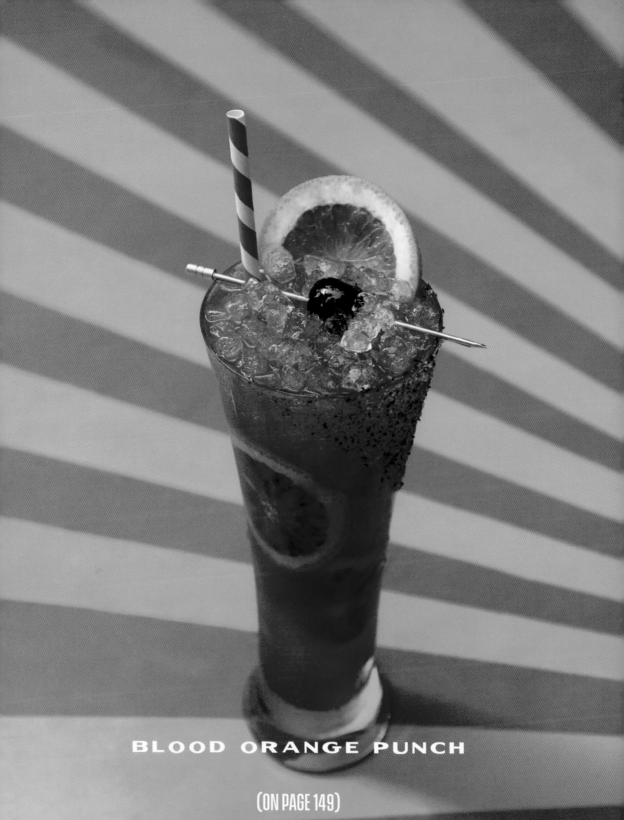

BLOOD ORANGE PUNCH

(ON PAGE 149)

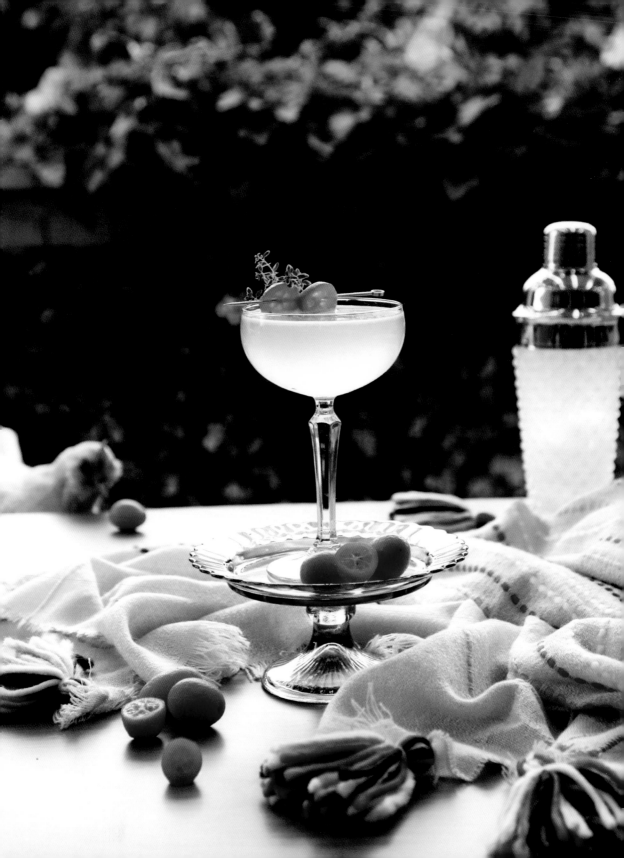

KUMQUAT THYME SPARKLER

· MAKES 1 SERVING ·

GLASS SUGGESTION: CHILLED COUPE

In this SoCal garden of mine, I have thyme growing year-round—in fact, most of my herbs soldier through the "winter" (but before you roll your eyes at me too hard, it gets so damned hot here in the summer that we oftentimes lose our herbs to self-combustion then). But thyme is one of those herbs that hangs tough during the winter in a lot of climates, and if you can't actually grow it where you are, you'll probably be able to find it at the market. When all else fails, bring on the dried! A good rule of thumb is to use a third of the quantity of dried herbs as the recipe calls for fresh.

Also: kumquats. Delicious, tart, adorable kumquats. If you can't grow or find them, just sub an equal amount of orange peels in the simple syrup and as garnish.

½ ounce Kumquat + Thyme Syrup

½ ounce orange liqueur, such as Grand Marnier or Cointreau

2 ounces Old Tom Gin

1 ounce freshly squeezed lemon juice

1 ounce ginger beer

GARNISH: 1 kumquat, sliced thinly + 1 sprig of thyme

• In a cocktail shaker with ice, combine Kumquat + Thyme Syrup, orange liqueur, gin, and lemon juice. • Shake until chilled. • Strain into a coupe, then top with ginger beer. • Garnish with kumquat slices and sprig of thyme.

KUMQUAT + THYME SYRUP

¼ cup kumquats, sliced

¼ cup fresh thyme leaves, or 1½ tablespoons dried

½ cup granulated sugar

½ cup water

Makes ¾ cup. • In a small saucepan over medium-high heat, bring all ingredients to a boil, then lower heat and simmer for 5 minutes. • Remove from heat, allow to cool, then strain liquids into airtight container and store in fridge for up to 2 weeks.

CLEMENTINE BRANDY NOG

· *MAKES APPROXIMATELY 12 SERVINGS* ·

GLASS SUGGESTION: EGGNOG/PUNCH CUP OR LOWBALL GLASS

Eggnog is another one of those polarizing drinks: people either love it, or they hate it. I'm of the very firm opinion that those who hate it just haven't ever had fresh, homemade nog. I grew up dutifully drinking store-bought because it felt seasonally warm and fuzzy to be drinking eggnog, even though I loathed it. At a certain point, I wised up and stopped drinking it all together, until years later, I found myself with chickens and the inevitable surplus of fresh eggs (have I mentioned I've got chickens?). I thought: "Eh, what the hell!" and decided to try making it from scratch just for gits and shiggles. And it was a revelation, my friends. An awakening. Join me.

An important note: Raw eggs. This recipe definitely uses them. So, handle and consume with caution. Theoretically, if you put enough booze in it, it purges the bad stuff (my motto for life, in general), but take that with a grain of salt. Not a literal grain of salt. Just be smart about it.

6 medium-size fresh eggs

1 cup granulated sugar

2 cups whole milk

1 cup heavy whipping cream

1 cup freshly squeezed clementine juice

1½ cups brandy

6 ounces orange liqueur, such as Grand Marnier or Cointreau

2 tablespoons finely grated clementine zest

GARNISH: freshly grated cardamom + 2 tablespoons finely grated clementine zest + 36 drops cardamom or orange bitters, divided

• Separate your eggs: yolks into one medium mixing bowl, whites in another. • Cover and refrigerate the whites. • Whisk together yolks and sugar until mixture is smooth and creamy. • Whisk in milk, cream, clementine juice, brandy, orange liqueur, and clementine zest until thoroughly combined. • Cover and refrigerate mixture for 1 to 24 hours (with enough alcohol in it, eggnog can be left in an airtight container, in the fridge, to age for several weeks, which will create a thicker, richer beverage).

• Just before serving, whisk egg whites (if you've aged your nog for longer than one day, you'll need fresh egg whites) until they form stiff peaks.
• Carefully fold egg whites into nog mixture.
• Serve immediately, dusting the foam on each individual glass of nog with grated cardamom, clementine zest, and 3 drops of bitters.

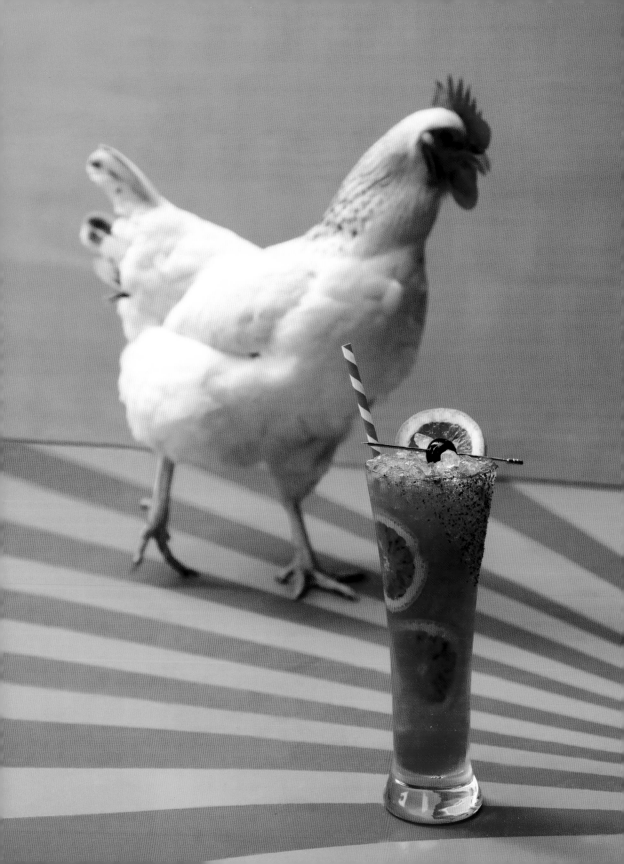

BLOOD ORANGE PUNCH

· MAKES 1 SERVING ·

GLASS SUGGESTION: HIGHBALL OR DOUBLE ROCKS GLASS

Oh, blood oranges how I do love thee. Is there a more perfect cocktail ingredient? (Okay, well, *booze* . . . booze ranks pretty high up there.) They taste great, they look great, and doggone it, people like them.

1 tablespoon coarse sugar + dry contents of 1 hibiscus tea bag for rimming glass

Lime wedge for rimming glass

2 ounces freshly squeezed blood orange juice

1 ounce freshly squeezed lime juice

2 ounces amontillado sherry

½ ounce maraschino liqueur

½ ounce Hibiscus Tea Syrup

GARNISH: 1 blood orange slice + Luxardo cherry

• Rim glass: Mix coarse sugar with 1 tablespoon dry hibiscus tea and spread it in a thin layer on a small plate. • Run lime wedge along rim of glass and dip rim into hibiscus mixture to coat. • Fill glass with crushed or pellet ice.

• In a shaker with ice, combine blood orange and lime juices, sherry, maraschino liqueur, and Hibiscus Tea Syrup. • Shake until chilled and strain into prepared glass. • Garnish with blood orange slice and cherry.

HIBISCUS TEA SYRUP

½ cup water

½ cup granulated sugar

2 hibiscus tea bags

Makes ¾ cup. • In a small saucepan over medium-high heat, combine all ingredients and bring to a boil. • Heat just until sugar dissolves. • Remove from heat and set aside to cool. • Remove tea bag, then pour liquids into an airtight container and store in fridge for up to 2 weeks.

PINE TREE G + T

· MAKES 1 SERVING ·

GLASS SUGGESTION: BRING ON THE GIN BALLOON! OR A HIGHBALL, LOWBALL, OR COLLINS GLASS

I rather like having a tree cocktail this time of year. As with any foraging or growing practices, be supersure you're getting chemical-free materials (a.k.a. don't use needles from the Christmas tree you bought at the gas station parking lot). My mom happens to live in the local mountains and her yard is filled with gorgeous evergreens that I routinely steal from. She doesn't know. Nobody tell her.

If you don't have access to wild, untreated pine, or don't feel like giving up a week of your life to infuse your own booze, Rogue Spirits makes a lovely Spruce Gin that is a great substitute. And if you can't get your hands on any over-the-counter evergreen-infused gins, I suggest using Rosemary-Infused Gin (page 28).

2 ounces Pine Needle–Infused Gin (page 29)

6 ounces tonic water

GARNISH: 1 sprig organic pine needles + spiraled lemon peel + pink peppercorns

• Fill your chilled highball glass with ice, add Pine Needle–Infused Gin, and then top with tonic water. • Gently crush your pine needle sprig to release some fragrance. • Garnish with pine needle sprig, lemon peel, and peppercorns.

CRANBERRY MAI TAI

· MAKES 1 SERVING ·

GLASS SUGGESTION: CHILLED ROCKS GLASS

I told you there would be a mai tai for every season. I think it has something to do with my little crazy chicken lady heart having a real soft spot for Hawaii. It is pretty much the drinking with chickens mothership, due to the fact that they are overrun with a large wild poultry population and the little feathered beasties are running everywhere from the beach to the rainforests to the supermarket parking lots. This is where someone is inevitably going to yell at me about them being destructive to the natural ecosystem, but I can't help what my heart feels: I HEART THEM. And by association, mai tais. It makes absolute perfect sense, okay?

So, here's a holiday-ish mai tai for you, with love, from me.

2 ounces aged rum

1 ounce freshly squeezed lime juice

½ ounce dry orange curaçao

½ ounce Cranberry Syrup (or substitute a tablespoon of your favorite cranberry sauce, in a pinch)

¼ ounce orgeat (almond) syrup

GARNISH: 1 lime wedge + 1 sprig rosemary + 3 cranberries

• Fill a rocks glass with crushed ice. • In a shaker with ice, combine rum, lime juice, curaçao, Cranberry Syrup, and orgeat and shake until chilled. • Strain into prepared rocks glass and garnish with lime wedge, rosemary sprig, and skewered cranberries.

CRANBERRY SYRUP

½ cup fresh or frozen cranberries

½ cup granulated sugar

½ cup water

Makes ¾ cup. • In a small saucepan over medium heat, combine ingredients and bring to a simmer. • Lower heat to medium-low and simmer for about 10 minutes, or until cranberries are just starting to pop. • Remove from heat, let cool, and then strain liquids into an airtight container and store in fridge for up to 2 weeks.

MEYER LEMON + CELERY FIZZ

· *MAKES 1 SERVING* ·

GLASS SUGGESTION: CHILLED COUPE

Celery in cocktails. I mean, why not? It deserves to be more than just Bloody Mary garnish. And it randomly tastes good with Meyer lemons (which I have in constant supply, due to the giving tree in my brother and sister-in-law's backyard).

If you don't have time to infuse your Celery-Infused Vodka (page 29), you can do a simpler, subtler version by muddling a tablespoon of fresh celery leaves in the bottom of the glass, adding 2 ounces of plain vodka, and allowing it to steep for about an hour. Strain away the leaves and build your cocktail.

2 ounces Celery-Infused Vodka (page 29)

1 ounce freshly squeezed Meyer
 lemon juice

½ ounce Good Ol' Plain Simple Syrup
 (page 50)

3 dashes of celery bitters

2 ounces club soda

GARNISH: 1 Meyer lemon peel spiral or
 slice + 1 sprig celery leaves

• In a cocktail shaker with ice, combine Celery-Infused Vodka, Meyer lemon juice, Good Ol' Plain Simple Syrup, and bitters until chilled. • Strain into coupe. • Top with club soda and garnish with Meyer lemon peel spiral and celery leaves.

ORANGE WHISKEY CHICORY COFFEE

I suppose you could just use regular coffee for this, but where's the fun in that? Professor Kate is back again with her beverage history lessons: chicory (roasted, ground endive root) was what people used to drink whenever there were coffee shortages, or what they'd add to coffee to make it stretch. And we're going to use it just for funsies.

2 ounces Orange Peel Whiskey (page 27)
5 ounces brewed chicory coffee blend
 (prepared according to package
 instructions)
2 tablespoons Orange Cream, divided
GARNISH: 1 orange peel spiral + dusting of
 freshly grated nutmeg

• Pour Orange Peel Whiskey into a prewarmed mug, then add brewed chicory coffee. • Add 1 tablespoon of Orange Cream and stir it in, then float remaining tablespoon on the top. • Garnish with orange peel spiral and grated nutmeg.

ORANGE CREAM

½ cup heavy whipping cream
2 tablespoons freshly squeezed orange juice
1½ teaspoons granulated sugar
1½ teaspoons orange zest

Makes 1 cup. • In a small bowl, using an electric mixer, whip together ingredients till thickened but still soft. • Set aside.

GOLDEN EGGNOG

· *MAKES APPROXIMATELY 8 SERVINGS* ·

GLASS SUGGESTION: ROCKS GLASS OR PUNCH CUP

Just bringing more eggnog to the people, because I'm selfless like that. This one is going to harness the magic of Golden Milk (an anti-inflammatory, turmeric-based health drink) into a luscious yolk-heavy nog. Did I lose you? Come back. It's delicious: sweet and slightly savory, and so damned healthy! Just kidding. It's not healthy at all. But it does have turmeric in it, so maybe you'll be slightly less inflamed? Pay no mind to the loads of booze.

6 medium-size eggs

½ cup granulated sugar

½ cup Golden Milk Syrup

2 cups whole milk

1 cup heavy whipping cream

2 cups aged rum

GARNISH PER GLASS: a scant pinch of turmeric powder + a scant pinch of freshly grated nutmeg + a scant pinch of freshly ground black pepper

• Separate your eggs; yolks go into one medium mixing bowl, whites go into another. • Cover and refrigerate the whites. • Whisk together yolks and sugar until smooth, then whisk in Golden Milk Syrup. • Add milk, cream, and rum, whisking until smooth.

• Just before serving, whisk egg whites until they form stiff peaks. • Gently fold whites into nog mixture. • Serve immediately, dusting the foam of each glass with turmeric, nutmeg, and black pepper.

GOLDEN MILK SYRUP

½ cup full-fat coconut milk

¼ cup honey

1½ teaspoons grated fresh ginger, or
⅛ tablespoon dried

1½ teaspoons grated fresh turmeric, or
½ teaspoon dried

⅛ teaspoon freshly ground black pepper

⅛ teaspoon ground cardamom

1 stick cinnamon

1 vanilla bean, split open

Makes ½ cup. • In a small saucepan, bring all ingredients to a simmer over medium-low heat and simmer for 12 to 15 minutes. • Remove from heat and allow to cool. • Discard cinnamon stick and vanilla pod.

PICKLED CARROT MARY

· MAKES 1 SERVING ·

GLASS SUGGESTION: PINT, HIGHBALL, OR COLLINS GLASS, CHILLED

Or, as I like to call it, the Bloody Carry. Yes, it's a Bloody Mary made with carrot juice, but listen, it's winter, so we don't have tomatoes. Carrots have our back for brunch beverages.

A pivotal part of this recipe is the pickled carrot garnish and the pickled carrot juice. But I have a really lazy hack for that. Grab your favorite jar of pickles. Eat all the pickles. I'll wait here. Leaving the pickle juice in the jar, fill it with small whole carrots and store in the fridge for at least one day and up to a week.

1 ounce freshly squeezed lemon juice for muddling

3 slices jalapeño pepper, or to taste for muddling (optional)

2 ounces carrot juice

1½ ounces vodka (if you want to be real slick, use the Celery-Infused Vodka on page 29 or the Spicy Tomato-Infused Vodka on page 28)

1 ounce pickled carrot brine

1 teaspoon Worcestershire sauce

½ teaspoon horseradish paste

3 dashes of hot sauce (I like Marie Sharp's for this because it is a carrot-based hot sauce)

Pinch of sea salt

GARNISH: 1 celery stalk or pickled or raw carrot (see note above) + 1 lemon slice

• In the bottom of a shaker, combine lemon juice and jalapeño slices (if using), and muddle. • Add ice. • Add carrot juice, vodka, pickled carrot brine, Worcestershire, horseradish, hot sauce, and salt and shake thoroughly until chilled. • Fill a chilled highball glass with ice and pour cocktail mixture into it. • Garnish with celery stalk/or carrot, and lemon slice.

APPLEJACK TODDY

· MAKES 1 SERVING ·

GLASS SUGGESTION: HEATPROOF MUG OR HOT TODDY MUG, WARMED

Yes, that's right. It *does* snow in Southern California. Not in my actual backyard, but in my friends' backyard, which is not too far from mine. Plus, they also have chickens. So, I went to there to be cold enough that drinking this Applejack Toddy was a necessity. Also a necessity: holding this chicken.

½ ounce Cinnamon Syrup (page 121)

½ ounce freshly squeezed lemon juice

2 ounces applejack

¾ cup hot water

GARNISH: 1 slice apple + 1 stick cinnamon + 1 star anise pod

• Pour Cinnamon Syrup, lemon juice, and applejack into warmed mug. • Top with hot water, stir, and garnish with apple slice, cinnamon stick, and star anise pod.

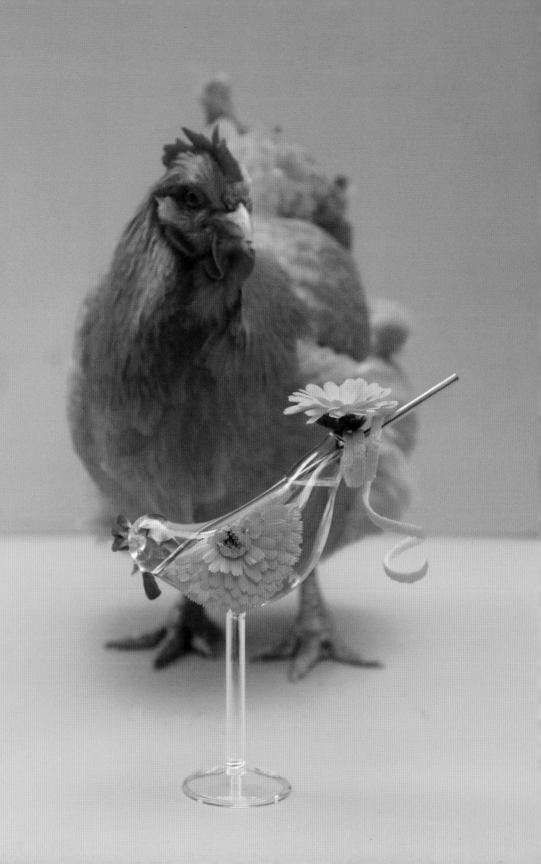

CALENDULA-ORANGE CLARIFIED PUNCH

· MAKES 8 SERVINGS ·

GLASS SUGGESTION: PUNCH CUPS OR RIDICULOUS BIRD-SHAPED GLASSES THAT ARE IMPOSSIBLE TO DRINK OUT OF

Clarified. Milk. Punch. Don't be scared. Sounds weird and challenging to make, but it really isn't either of those things. It's delicious and it's simple. And if you don't love creamy cocktails, this is definitely for you. The clarification process removes all that creaminess that coats the tongue, but leaves behind a lovely gentle flavor and silkiness. I'm a fan. A note about calendula: it is a winter bloomer (at least here in SoCal), but if you don't have access to fresh, you can order dried calendula blossoms online.

12 ounces clear rum

4 ounces orange liqueur, such as Cointreau

¼ cup dried organic calendula blossoms

Peel of 1 orange

2 cardamom pods

1 stick cinnamon

1 star anise

¼ whole nutmeg seed

8 ounces granulated sugar

8 ounces water

4 ounces freshly squeezed lemon juice

4 ounces freshly squeezed orange juice

4 ounces whole milk

GARNISHES: fresh or dried organic calendula blossom petals + 8 orange twists + dusting of freshly grated nutmeg

• Combine rum, orange liqueur, calendula blossoms, orange peel, and spices in a large, airtight container. • Seal, then let infuse for 24 hours.

• After 24 hours, strain away the solids, then add sugar, water, and lemon and orange juices to the booze mixture and stir to dissolve sugar. • Pour the milk in a separate large glass container (such as a half-gallon canning jar). • Slowly pour cocktail mixture into milk and stir. • Place this concoction in fridge and let settle for a few hours or up to 24 hours. • You will see the milk starting to curdle and separate. It looks gross, but that's how you know it's working.

• Strain curdled mixture through a coffee filter– or cheesecloth-covered fine-mesh strainer. • It will go very slowly, so pour it a little at a time and let it sit in the fridge to drain. Eventually, you should have about 4 cups of clarified punch.

• To serve, pour 4 ounces of punch over ice into each glass and garnish with calendula petals, orange twist, and nutmeg.

LOS ANGELES SOUR

· *MAKES 1 SERVING* ·

GLASS SUGGESTION: CHILLED ROCKS GLASS

Yep. Winter in LA involves lots of blooming bougainvillea. I don't make the rules.

This is a flip on the classic New York Sour, a visually stunning layered drink, typically made with rye or bourbon, lemon juice, and simple syrup, with a float of red wine on top. Some folks will also add egg white to the mix. And you know I'm one of those folks.

2 ounces Orange Peel Whiskey (page 27)

1½ ounces freshly squeezed blood orange juice

½ ounce freshly squeezed lemon juice

½ ounce Good Ol' Plain Simple Syrup (page 50), or Orange Grenadine (page 108)

1 medium egg white

1 ounce chilled citrus fruit–forward white wine

GARNISH: edible, organic blossoms + blood orange peel

• In a shaker, combine Orange Peel Whiskey, blood orange and lemon juices, Good Ol' Plain Simple Syrup, and egg white. • Shake vigorously for around 20 seconds, or until egg white is foamed. • Add ice to shaker and continue to shake until chilled. • Strain mixture into a rocks glass filled with ice. • Add white wine float by drizzling it slowly over the back of a bar spoon into the cocktail. • Garnish with a flower and/or blood orange peel.

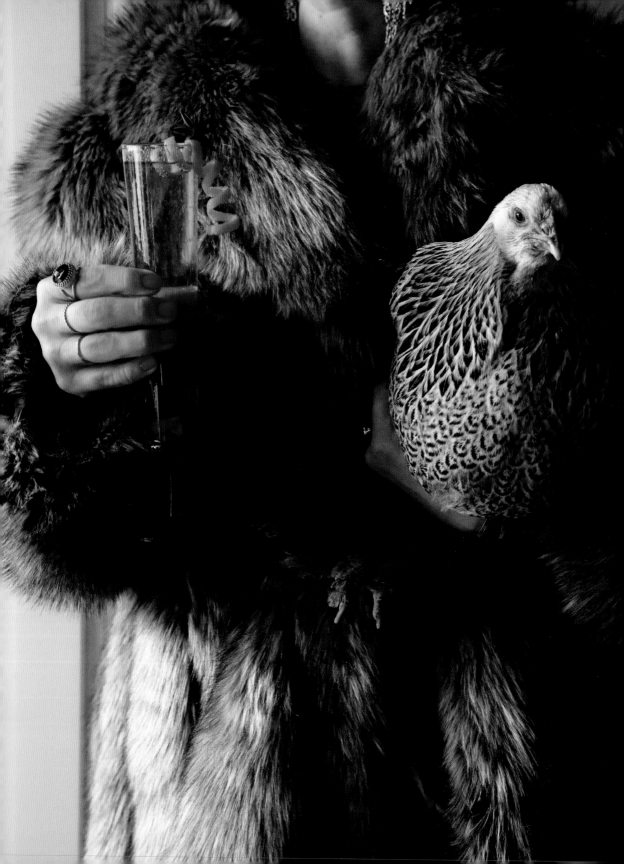

SPICED TANGERINE CHAMPAGNE COCKTAIL

· MAKES 1 SERVING ·

GLASS SUGGESTION: CHAMPAGNE COUPE OR FLUTE

It is a fact backed by science that one can never have too many Champagne cocktail variations. So, here's a version that uses some lovely winter tangerines made into an even lovelier Spiced Tangerine Syrup.

1 tangerine peel for rimming glass

½ ounce Spiced Tangerine Syrup

5 drops citrus bitters

3 ounces dry Champagne or sparkling wine

GARNISH: spiraled tangerine peel + star anise pod

• Run tangerine peel around the rim of the glass. • Pour the Spiced Tangerine Syrup into the bottom of your glass, then add bitters over that. • Top with Champagne and garnish with a tangerine peel and a star anise pod.

SPICED TANGERINE SYRUP

¾ cup freshly squeezed tangerine juice

1 stick cinnamon

1 star anise

2 whole cloves

¾ cup granulated sugar

Makes 1 cup. • In a small saucepan, bring tangerine juice and spices to a boil and boil for 3 minutes. • Add sugar and continue to boil until sugar is fully dissolved, then lower heat to medium-low and simmer mixture for 10 minutes to thicken. • Remove from heat, let cool, then strain into an airtight container and store in fridge for up to 2 weeks.

SNOWBALL MOJITO

· *MAKES 1 SERVING* ·

GLASS SUGGESTION: CHILLED COLLINS OR HIGHBALL GLASS

Also known as the Snowjito. As we have established, there is no snow in my garden. Ever. But I only have to drive about an hour away to find some. And when it's fresh, I make cocktails out of it, because this is who I am now. But that isn't totally necessary for this drink; shaved ice is even better than snow. It's definitely cleaner; no chance of yellow shaved ice, if you get my drift (snow puns). And if you don't have access to either, crushed ice will do just fine.

3 cups snow or shaved ice

3 fresh mint leaves for muddling

1 ounce freshly squeezed lime juice, divided

1 ounce Coconut Mint Syrup (page 92), divided

3 to 6 lime wheels

2 ounces clear rum

1 ounce club soda

GARNISH: lime wheel + 1 mint sprig

• Just before you start to build your cocktail, form clean snow or shaved ice into snowballs just big enough to fit into your glass. • You'll need about 4. (If you are using crushed ice, just add it in 4 layers and pretend it's snow. No one has to know.)

• In the bottom of a chilled glass, combine mint leaves, ½ ounce of the lime juice, and ¼ ounce of the Coconut Mint Syrup and muddle briefly. • Add first snowball or batch of ice, plus a lime wheel or 2 against the side of the glass. • Add another ¼ ounce of lime juice, ¼ ounce of syrup, and 1 or 2 lime wheels. • Repeat. • Add rum and club soda. • Stir briefly (just enough to mix the liquids a tad, but not enough to break up the snowballs). • Add your final snowball and drizzle the last ¼ ounce of syrup over the top of it. • Garnish with a lime wheel or 2 and a sprig of fresh mint.

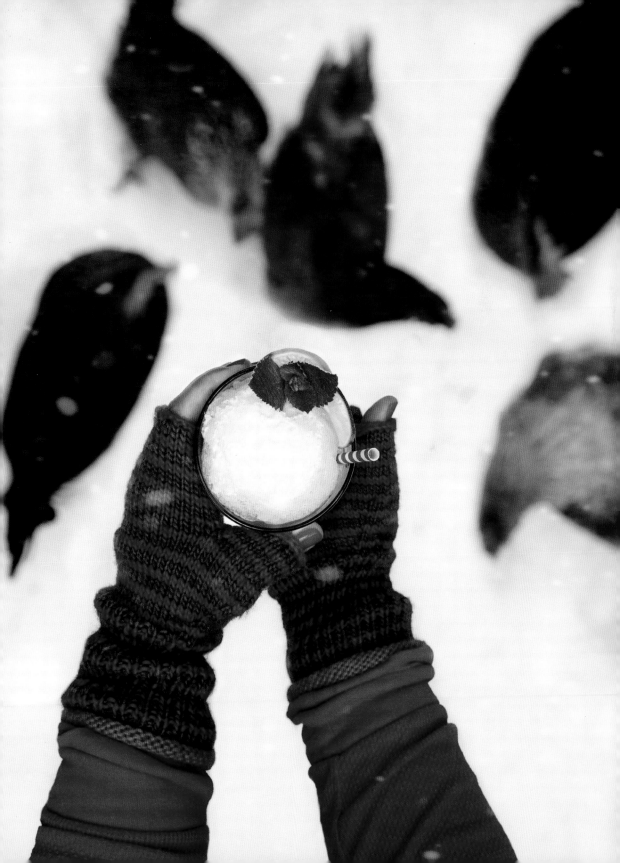

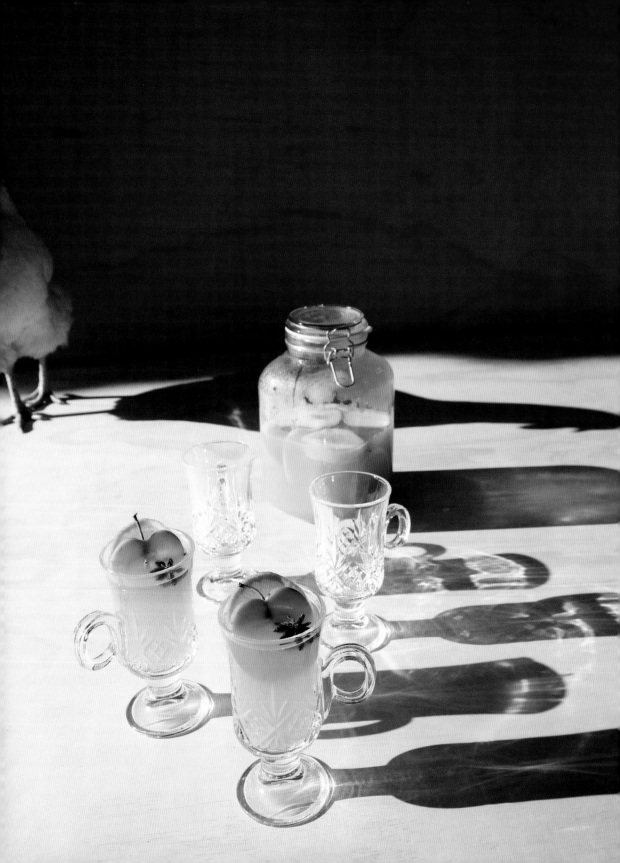

WINTER SUNSHINE MULLED WINE

· *MAKES 4 SERVINGS* ·

GLASS SUGGESTION: CLEAR HEATPROOF MUG, IRISH COFFEE MUG, OR HOT TODDY GLASS

Typically, mulled wine (or hot sangria, as I like to call it) is made with the dark stuff. Especially this time of year. But by now, you know that I like to purposefully do weird things, so let's do this with white wine. Why? Because we can. Also, I feel like if it's all wintery and cold out, and you want to sip a hot beverage, it's nice to be reminded of sunshine. Here is some liquid sunshine for your cold, cynical, winter belly.

1 (750-ml) bottle dry white wine

½ cup freshly squeezed orange juice

¼ cup elderflower liqueur, such as St-Germain

¼ cup Honey Syrup (page 54)

Juice of ¼ lemon or Meyer lemon

1 orange, sliced

1 light-skinned apple, thinly sliced, seeds removed

2 sticks cinnamon

2 whole cloves

4 cardamom pods

1 vanilla bean, split

GARNISH: 4 apple slices, divided + 4 orange slices, divided + 4 star anise pods, divided

• Combine all ingredients except garnish in a small saucepan and bring to a simmer over medium heat. • As soon as it begins to simmer, lower heat to low and heat for 30 minutes. • Ladle warm mixture into each of 4 glasses, and garnish each with an apple slice, an orange slice, and a star anise.

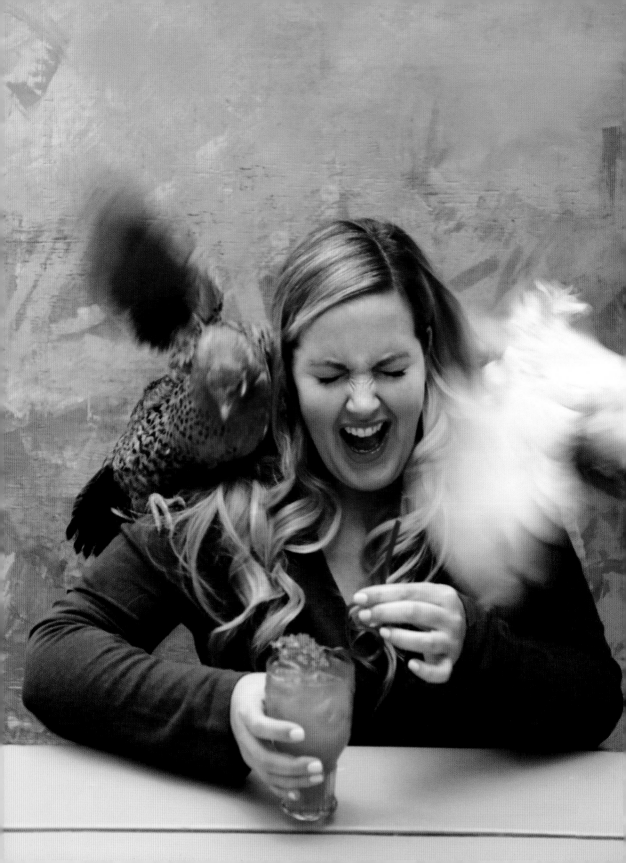

ALL YEAR ROUND

CHAPTER 5

Mocktails

Hahahahahahaha!

Just kidding.

ACKNOWLEDGMENTS

It's almost embarrassing how many people I need to thank for stepping up and helping me with this dang thing, but I am so very grateful to each and every one of you. You are my flock, whether you like it or not.

First, I better thank my husband, Jonathon, for putting up with all of this. For resolutely standing by during a lot of ridiculous photo shoots and learning to place a chicken in just the right afternoon light (*no, not there . . . THERE! See how her butt fluff is backlit?*). Frankly, I've got to thank him for just putting up with the chickens in the first place. He's more of a dog person.

A million thanks to my agent, Rica Allannic, for her faith in this rather out-of-the-box book concept (and in me). This was no small feat and I am so very humbled that she saw potential. Same goes to Kristen Green Wiewora and the team at Running Press (Amber Morris, Celeste Joyce, Frances Soo Ping Chow, and Seta Zink—you all put up with A LOT) for all their talent, hard work, and especially for their patience with me and the poultry.

There's a handful of friends that humbly came over to hold chickens and repeatedly put their hands and bodies in photos. Basically, they volunteered to be props, and I am so grateful to them. Laura Durrer, Allison and Chris White, Joanna Hawley, Sean McBride, Kari Sanburg, Gina Ruccione, Taryn Candelora, Kary Reichman, Dan Magro—you are the best models money didn't buy! Thank you to Whitney Seward and family, for letting me use their chickens and their home (not to mention their time and patience) for my "Southern California Winter" shots. And for not throwing us out when we overstayed our welcome at happy hour afterward. Also thanks to Kristen Guy, for graciously allowing me to forage for materials in her garden when mine was being a brat, and Elana Lepkowski, for letting me forage in her barware collection.

I've got to give a shout out to my nephew, Presston, for helping me with one tricky photo shoot and actually being the one who took the winning photo. I'm still taking credit for it though, because I'm a monster.

Very special thanks to Sarah Ehlinger for stepping in to help me with styling and photography on multiple occasions; your creativity and eye never cease to amaze me and you are always so generous with your time. I appreciate you more than you can know. Also, you're a fabulous chicken model and it should definitely go on your résumé.

Many awkward hugs delivered only in gif form to Tina Anderson, AKA the Brain Trust; always willing to let me hurl ideas at you and then help me to nurture them into usability. Or help me see I'd better scrap them completely. You were on board with this ridiculousness from the very start and never once told me I was crazy. To my face. It means the world to me.

Finally, thanks and love to my mom and dad. Look, guys! I wrote a book! It's about livestock and booze, just like you always envisioned for my future. And to my brothers, Kevin and Ryan: *WHO'S THE FAVORITE CHILD NOW?!*

Cheers and hugs to you all.

INDEX

NOTE: Page references in italics indicate photographs.